North Pacific Ocean

North Atlantic Ocean

South Pacific Ocean

Canada

United States of America

Bermuda

Mexico

Bahamas

Cuba

Cayman
Islands

Jamaica

Dominican
Republic

Haiti

Puerto
Rico

British Virgin
Islands

Virgin
Islands

St. Kitts and Nevis

Antigua and Barbuda

Dominica

St. Lucia

Barbados

St. Vincent
and The Grenadines

Grenada

Trinidad
and Tobago

Netherlands
Antilles

Aruba

Belize

Guatemala

Honduras

El Salvador

Nicaragua

Costa Rica

Panama

Venezuela

Colombia

Guyana

Suriname

Ecuador

Peru

Brazil

Bolivia

Paraguay

Chile

Argentina

Uruguay

Nauru

Solomon Islands

Vanuatu

Fiji

Western Samoa

American Samoa

Cook
Islands

Tonga

New Zealand

the OLYMPIC GAMES QUILTS

AMERICA'S WELCOME to the WORLD

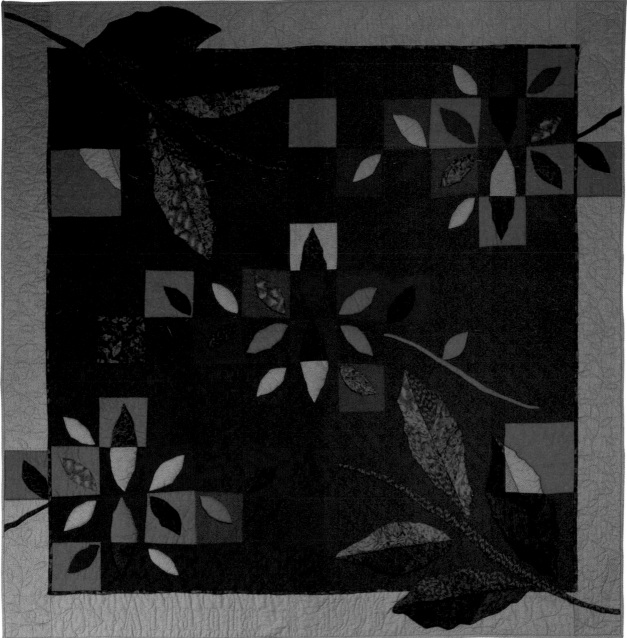

The Quiltmakers of Georgia

Oxmoor House®

THE OLYMPIC GAMES QUILTS
America's Welcome to the World

©1996 by Oxmoor House, Inc.
Photographs ©1996 by the Atlanta History Center
 and The Georgia Quilt Project

Published by Oxmoor House, Inc.
Book Division of Southern Progress Corporation
P.O. Box 2463, Birmingham, AL 35201

Library of Congress Catalog Card Number:
 95-69686
ISBN: 0-8487-1503-9
Manufactured in the United States of America
First Printing 1996

Editor-in-Chief: Nancy Fitzpatrick Wyatt
Senior Crafts Editor: Susan Ramey Cleveland
Senior Editor, Editorial Services:
 Olivia Kindig Wells
Art Director: James Boone
Vice President, Custom Publishing: Dianne Mooney

THE OLYMPIC GAMES QUILTS
America's Welcome to the World

Editor: Carol Logan Newbill
Editorial Assistants: Barzella Estle,
 Wendy L. Wolford
Copy Editor: Susan S. Cheatham
Production and Distribution Director:
 Phillip Lee
Associate Production Managers: Theresa L. Beste,
 Vanessa D. Cobbs
Production Coordinator: Marianne Jordan Wilson
Production Assistant: Valerie Heard
Designer: Clare T. Minges
Patterns and Illustrations: Kelly Davis
Publishing Systems Administrator: Rick Tucker
Photo Stylist: Katie Stoddard
Photographers: William C.L. Weinraub, *Georgia Quilt
 Project*; William F. Hull, *Atlanta History Center*;
 John O'Hagan, *Oxmoor House*

Contents

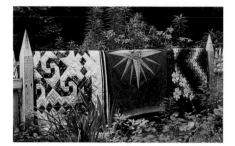

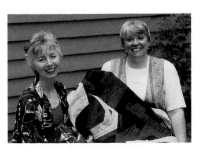

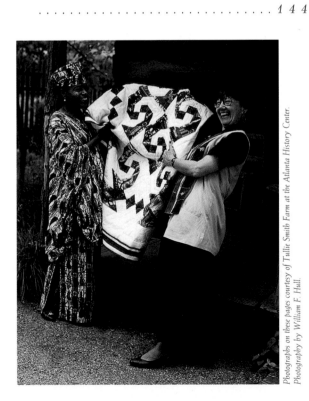

Photographs on these pages courtesy of Tullie Smith Farm at the Atlanta History Center.
Photography by William F. Hull.

Acknowledgements from the
GEORGIA Quilt PROJECT

This book was truly a collaborative project, a coming together of many diverse entities to create an exquisite tribute to the generosity of Georgia's quilt-makers as well as our "welcome to the world." In addition to the quiltmakers who participated in the Olympic Games Gift of Quilts, many others also deserve to be recognized.

Ginger Watkins, Managing Director of Corporate Services of the Atlanta Committee for the Olympic Games, was a strong supporter of the gift quilt idea from its very beginning. Ann Beddow of the International Olympic Committee, Laurie Olsen (Director of Communications), Andrea Pavone-Said (Creative Services), and Mark Irwin (Protocol Officer, Olympic Village) all went to great lengths to give this project its polish.

Oxmoor House was an early collaborator. Susan Cleveland, Dianne Mooney, and Carol Newbill worked tirelessly throughout the editorial process.

Darlene Roth, Janice Morrill, Betsy Weyburn, Sarah Johnston, and many others at the Atlanta History Center offered continuing advice and support.

Holly Anderson, Vice Chairwoman of the Georgia Quilt Project, helped keep all communication lines open and everything running smoothly.

Dozens of Georgia Quilt Project volunteers assisted with the photography and documentation of the quilts. William C.L. Weinraub cheerfully spent many long days photographing each of the quilts. Mary Ross and the Iris Quilters of Griffin, Georgia, documented most of the quilts, creating a permanent record for each one. Along with Carolyn Kyle, Mary organized the care, storage, and transportation of the Olympic Games gift quilts, getting them safely to and from the various exhibition sites. Both women worked long hours with their stitch-in groups sewing the gift quilt labels onto the backs of the quilts. All of the board members of the Georgia Quilt Project made significant contributions to the effort.

Photo Barn, Inc., of Lilburn, Georgia, deserves a special "thank you" for providing the studio space used to photograph the Olympic Games gift quilts.

Anita Zaleski Weinraub
Chairwoman, Georgia Quilt Project

Atlanta Committee for the Olympic Games
250 Williams Street, Suite 6000
P.O. Box 1996
Atlanta, GA 30301-1996 USA
Telephone 404-224-1996
Facsimile 404-224-1997

Dear Reader:

It is with a heart full of pride and gratitude that I salute the extraordinary volunteers of the Georgia Quilt Project and their gift of labor and love to the Centennial Olympic Games. Hundreds of talented and dedicated quiltmakers from across the state of Georgia have donated hundreds of thousands of hours to design and stitch the 397 glorious quilts you see in this book. In a special presentation as each team arrives in the Olympic Village, these quilts will be given as a goodwill gesture to representatives from each of the countries participating in the Games.

The quilt seems a fitting symbol for the very fabric of the Olympic Games. Not only does it preserve our heritage and traditions in rich textural imagery, but it also reflects the Olympic movement as a patchwork of cultures and a family of nations. In every sense the whole is greater and more beautiful than the sum of the parts.

On behalf of everyone associated with the Centennial Olympic Games, I thank the quiltmakers of Georgia for this exquisitely selfless gesture. It is not just the personal time, materials, and talent of the Georgia quilters that I celebrate—it is the spirit of their generosity that I honor. With motivation this pure, nations of the world can learn well from the traditions of the quiltmaker to work together with strength to achieve peaceful goals.

William Porter Payne
Chief Executive Officer and President

Introduction

"Native Americans presented blankets as gifts only to honored friends, those whose deeds were admired or whose position was esteemed. In that tradition, I present this quilt to you, your Centennial Olympic Games 1996 team and your country."

—from inscription on reverse of Olympic gift quilt
Lone Star—That's Not What You Are, made by Sally Schuyler, Atlanta, Georgia (page 109).

The year was 1992. The Olympic Summer Games in Barcelona, Spain, had just ended. Already volunteers from the Georgia Quilt Project were hard at work planning a project—a Gift of Quilts—to commemorate the Centennial Olympic Games that would be held in Atlanta in 1996.

The Georgia Quilt Project is an organization formed in the late 1980s to collect historical information about the state's quilts and quiltmakers. Traveling extensively across the state, Quilt Project volunteers documented more than 8,000 quilts and made contact with thousands of quilters and quilt lovers. With this background, the Quilt Project's organizers felt that the group was in a unique position to do *something* to celebrate so momentous an event as the Olympic Games being held in the South for the first time.

After meeting with the Atlanta Committee for the Olympic Games, the Quilt Project proposed that the quiltmakers of Georgia create a number of special handmade quilts. Two quilts would be presented to each country participating in the 1996 Centennial Olympic Games—one to the flagbearer and one to the National Olympic Committee—at a special ceremony welcoming each country's delegation to the Olympic Village. Since approximately 200 countries were expected to participate in the Games, the proposal meant that about 400 quilts were needed! An ambitious undertaking, but the volunteers of the Georgia Quilt Project immediately began working toward their goal, setting these simple rules:

★ The gift of quilts was not limited to members of Georgia's quilt guilds. Former residents of the state, as well as groups such as Girl Scout troops, contributed to the effort.
★ The quilts could be of any design *except* the Olympic rings and torch.
★ All quilts must be a specific size (54" x 70"). This large lap size worked well as either a personal size quilt (for the flagbearers) or as a wall quilt (for the National Olympic Committees).
★ Quilts must be quilted either by hand or machine (no tied quilts), and a hanging sleeve must be attached to the back of each.
★ Each quilt must be signed by the maker. The organizers also encouraged quilters to include with their quilts a label or a letter, a photograph, and possibly a message for the recipient.

★ A quiltmaker could not specify which country would receive his or her quilt. Each quilt was to be made simply as a gesture of friendship and welcome from a citizen of Georgia to some unknown citizen of the world.

Georgia's quilters received the proposal with enthusiasm. Barely one month after the formal announcement of the Olympic Games Gift of Quilts, the Quilt Project received the first completed quilts. Excitement continued to build as individuals, quilt guilds, and other groups pledged their efforts to the project. As quilts were completed, they were displayed at local quilt shows and regional quilters' gatherings, further helping to spread the word. The Atlanta History Center began to hold monthly quilting bees to work on the quilts, and local shops offered "Olympic Games Quilt Classes."

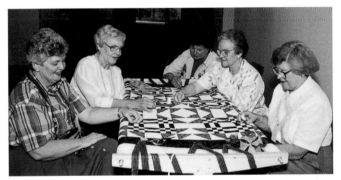

Expert volunteers of the Georgia Quilt Project lead a quilting bee at the Atlanta History Center.

By the summer of 1995, all of the quilts were completed. The Quilt Project and the Atlanta History Center made plans for a grand exhibition of all the quilts, so that viewers could see and admire them as a body before they were scattered to their destinations around the globe. To decide which quilts would be presented to which country, the Quilt Project volunteers held a random drawing, keeping the results secret until the concurrent opening of the exhibition and publication of this catalog in January of 1996.

The names given to the quilts reflect the exuberance of the occasion: among them, *Go for the Gold, Olympic Dreams, A Warm Atlanta Welcome, Olympic Friendship, Reach for the Stars, Georgia Pine Welcomes the World, Many Hearts Filled with Love, Ladder to the Gold, Friendship Circle, Field of Dreams,* and *Peace.*

Who are the giving Georgians behind the Olympic Games Gift of Quilts? A group of talented, dedicated,

and purposeful quiltmakers who personify the giving side of human nature, the makers come from all walks of life and reflect Georgia's ethnic and cultural diversity. Many are working, professional people—an airline flight attendant, a real estate agent, a psychologist, and others—who took time to stitch their contributions to this unprecedented gift.

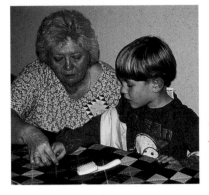

Passing skills to the newest generation, Quilt Project volunteers helped school-children learn to quilt their completed works of art.

When she was 10 years old, **Ruby Jackson of Fairburn** learned to quilt from her grandmother, who taught her the traditional method of stitching entirely by hand. Ruby continued to stitch by hand until several years ago, when a class in machine quilting showed her one way to make more quilts in less time. Her gift quilt, *African-American Kente Cloth Quilt* (page 115), is a celebration of her heritage blended with the new technique of machine stitching.

Wife and mother of two, **Linda Camp of Ellerslie** helps run her family's wholesale nursery and drives a school bus during the day. Although she already has more than enough to do, Linda chose to spend many late nights machine-piecing and hand-appliquéing her contribution to the Olympic Games Gift of Quilts. For her *Sunburst Quilt,* detail above and shown on page 97, Linda drafted a pattern from a photograph of an antique quilt shown on the cover of a book about mid-19th century quiltmaker Dorinda Moody Slade. As Linda says in her dedication, this quilt is "a gift from our past, given to an athlete of today so that it may be cherished tomorrow."

Fiber artist **Jul Kamen, from Nassau, the Bahamas,** was the featured quiltmaker at a regional quilters' conference held in Atlanta in February 1993. She was

so excited about the Gift of Quilts that she joined a Georgia-based quilt guild in order to be eligible to make one! A long letter accompanies her contribution, *A Little Street Music* (page 46), which depicts the annual Bahamian festival of Junkanoo. Explains Jul: "Junkanoo—a celebration of life and creativity just as the Olympics are also a celebration of life through competition. Junkanoo takes place at 3:00 a.m. on Boxing Day (December 26) and New Year's Day and takes the form of a very lively and loud street parade of dance, music, and costume. Neighborhood groups work all year long building intricate costumes, choreographing dance, and preparing music to

A Quilt of Leaves is visible everywhere this summer as the "Look of the Games" in Atlanta. Symbolizing the patchwork of cultures joined together for the Games, the design includes laurel leaves for victory and olive branches for peace.

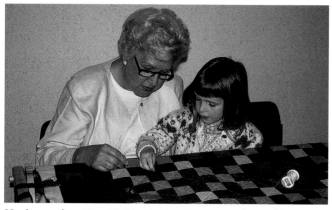

Hard at work on The Children's Nine-Patch, *a quilter and her young friend from Doraville's Northwoods Montessori School complete another Olympic gift quilt.*

compete against each other. Only specific instruments are allowed: cowbells, goatskin drums, and horns. This quilt is a tribute to healthy competition and the preservation of the human spirit—as is the Olympics."

The **16 children of Lisa Jones's afternoon class at Northwoods Montessori School in Doraville** spent one afternoon each week during the 1994–1995 school year, along with volunteers from the Georgia Quilt Project, creating their quilt (page 72). According to Lisa, the quilt project had several objectives. The children, ranging in age from 4 to 6, improved their motor skills by practicing hand

Making quilts is lots more fun than learning mathematics the old-fashioned way!

stitching as they expanded their knowledge of geography by discussing the Olympic Games and the many countries around the world that might receive their quilt. They learned math concepts while creating their nine-patch squares and even learned how to use a sewing machine as they joined hand-sewn squares. Sewing on the machine was a particularly popular activity, Lisa says. The children also pieced a traditional schoolhouse block for the back of the quilt, each embroidering his or her first name around the schoolhouse. The completed top was hand-quilted by volunteers at the Atlanta History Center during the monthly quilting bees.

Sisters **Carrie Bibelhauser of Norcross, Georgia,** and **Effie Hall of Charlotte, North Carolina,** describe their first collaborative effort as an experiment in color and use of the 60° triangle. During the three weekends they spent creating their quilt, *Kaleidoscope* (page 84), Carrie cut and Effie stitched the hexagons. They were so pleased with the wildly exuberant result that they did not want to give it up! But because they had promised the quilt to the Olympic Games Gift of Quilts, the sisters simply made two more identical quilts—one for each of them. Carrie and Effie plan to visit the country receiving their work of art, wherever in the world it is. Its label states: "This quilt would not have been possible without the Olympic spirit of perseverance and cooperation. We like to think that our efforts, in a small way, resemble those of the many athletes and nations around the globe that have come together to make these Olympic Games a reality."

The **Cotton Boll Quilters of Covington** contributed *When Cotton Was King* (page 128), a design by member

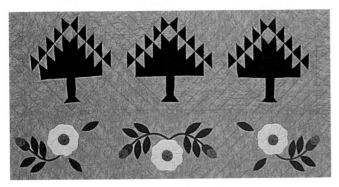

Pine trees and the state flower are part of When Cotton Was King.

Marilyn Titman incorporating many symbols of Georgia. The cotton boll, representing the most common fiber used by quiltmakers as well as a crop of great significance to Georgia, is prominently featured. Other images on the quilt include spools (representing the craft of quilting), peaches, and pine trees (both abundant in the region), and Georgia's state flower, the Cherokee rose. The inscription on the reverse of the quilt, explaining the symbols shown, concludes: "We extend the hand of fellowship and wish you well."

Graphic designer and textile artist **Barbara Abrelat of Decatur** named her quilt *City of Gold* (page 38). One of the most dramatic gift quilts, her original piece shows a phoenix, the symbol of Atlanta, emerging from the flames, its wings spread in welcome. The Atlanta skyline appears in the background, below the hand-painted banner reading "1996 Atlanta Georgia USA." Hand-dyed fabrics in the flames and three-dimensional wing tips add to this contemporary interpretation of the mythical bird. *City of Gold* will be given to the Olympic

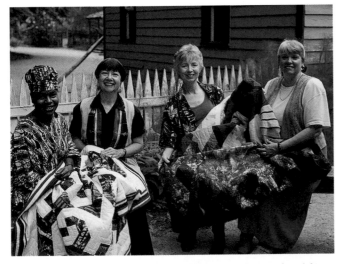

With two of the gift quilts at the Atlanta History Center are (from left) Huisha Kiongozi, Barbara Abrelat, Sammie Simpson, and Kathy Hefner.

Museum in Lausanne, Switzerland. Barbara's phoenix has also appeared on a variety of merchandise associated with the exhibit and the Olympic Games Gift of Quilts; the proceeds are dedicated to supporting the Georgia Quilt Project's documentation efforts.

The quiltmakers of Georgia, in the true spirit of generosity that quiltmakers have always demonstrated, have created a unique and very special gift for the participants of the 1996 Centennial Olympic Games. This gesture of welcome and friendship on the part of Georgia's quiltmakers will long be remembered for the spirit of goodwill in which the quilts were made. With this gift, we quiltmakers share part of our cultural heritage with the entire world, as Georgia quilts travel to every corner of the earth.

Although many states have conducted quilt documentation projects, the Georgia Quilt Project has gone one step further—it has used the network of volunteers and contacts it developed during the course of its

Photographs on page 8, upper right, and or this page by William F. Hull, courtesy of Tullie Smith Farm at the Atlanta History Center.

Quiltmaker Deirdre Greer and friend at Tullie Smith house, Atlanta History Center.

documentation to create an additional body of quilts. These quilts and the Olympic Games Gift of Quilts itself have been fully documented by the Project and information about all of the quilts, their makers, and their recipients will be placed in a prominent state archive.

In our own way, the quiltmakers of Georgia have had an influence on a global event of the magnitude of the Olympic Games. Quilters everywhere, when they hear of our efforts, will be inspired to take pride in the art of quiltmaking. We all will continue to work quietly to achieve peaceful goals and to piece together patches that, when held together by unifying stitches, will make a stronger whole than the individual pieces. Isn't that what brotherhood and cooperation among peoples is all about?

Anita Zaleski Weinraub
Chairwoman, Georgia Quilt Project

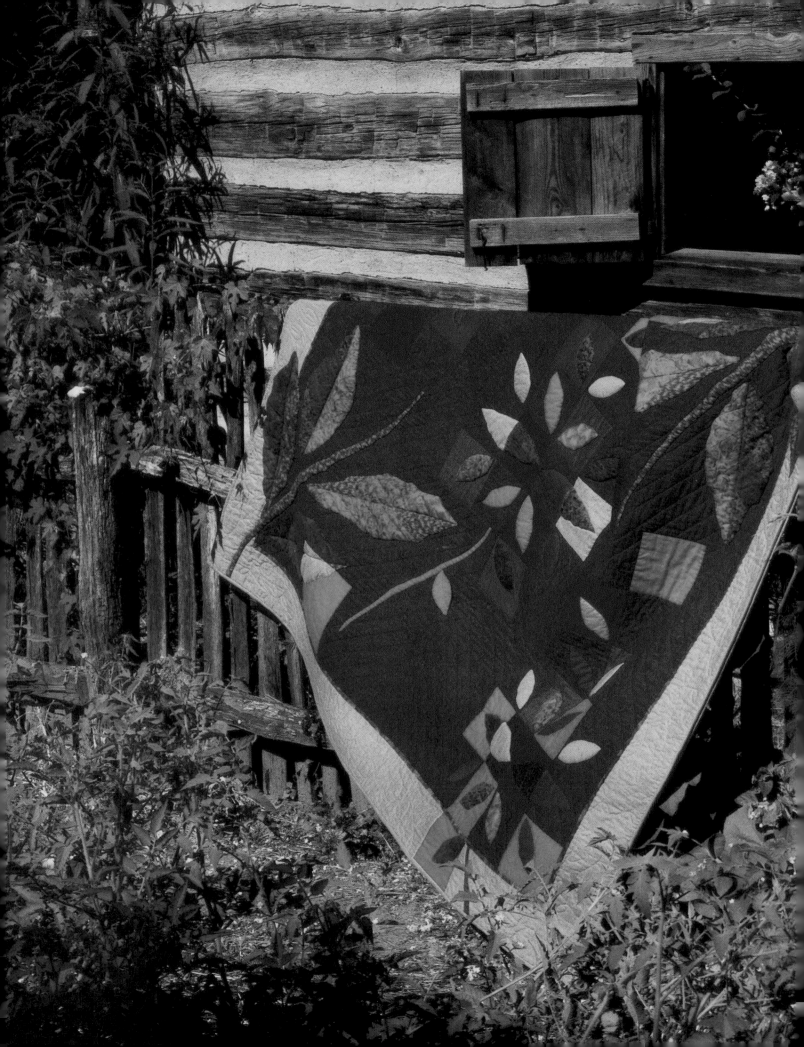

Photography on these pages courtesy of Tullie Smith Farm at the Atlanta History Center, by William F. Hull.

A QUILT *of* LEAVES

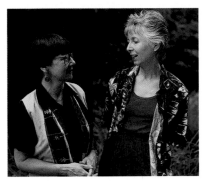

\mathcal{E}ach Olympic Games has a special "Look": a theme that uniquely identifies its place and time. Representing the first time that a quilt has been chosen to symbolize the "Look of the Games," *A Quilt of Leaves* was designed by a six-member team of firms from Atlanta, San Francisco, and Providence, Rhode Island. It symbolizes the Southern tradition of quiltmaking, the many trees of Atlanta, laurel leaves for athletes, and olive branches for peace. Once the Look was established, the Georgia Quilt Project chose two volunteers, Barbara Abrelat of Decatur (left, above) and Sammie Simpson of Alpharetta (right), to make the actual quilt, which will remain in the possession of the Atlanta Committee for the Olympic Games, rather than be given to a country.

Barbara, a graphic designer and former fashion illustrator, undertook the task of transforming the design team's drawing into a quilt top. Using the established palette of colors, she chose the placement of each color, drafted patterns, and stitched the fabrics into a breathtaking whole. Sammie, who teaches machine quilting, then quilted it. *A Quilt of Leaves* was unveiled on July 12, 1994, two years prior to the opening of the Games.

"We were excited and honored to be chosen to implement the design of *A Quilt of Leaves*," Barbara says. "The Centennial Games are a unique opportunity for Atlanta, and we are pleased to be part of the celebration."

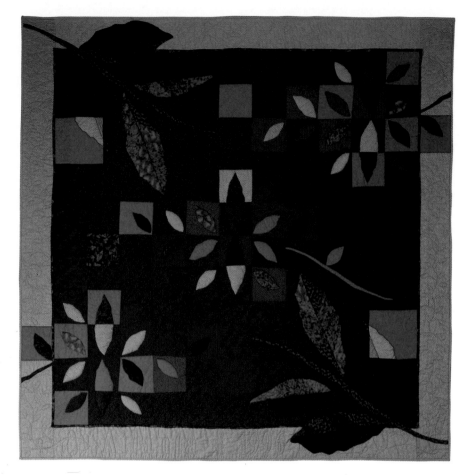

A QUILT of LEAVES

FINISHED QUILT SIZE
72" x 72"

FABRIC REQUIREMENTS

Gold print	1¾ yards*
Purple print	3½ yards
Dark green print	2 yards
Assorted green prints	1 yard
Red print	½ yard
Magenta print	¼ yard
Light purple print	¼ yard
Aqua	⅝ yard
Backing	4¼ yards

*Includes fabric for binding.

PIECES TO CUT**

Gold print
★ 2 (6½" x 60½") border strips
★ 2 (6½" x 49¾") border strips
★ 2 (6½" x 17¼") border strips
★ 10 E

Purple print
★ 1 (60½" x 42") rectangle
★ 1 (60½" x 19") rectangle
★ 1 Stem F
★ 1 Stem F rev.

Dark green print
★ 4 (1½" x 61") inner border strips
★ 14 E
★ 2 G

Red print
★ 8 E

Aqua
★ 2 (6½") squares
★ 5 E
★ 1 H

**See steps 4-7 before cutting pieces.

QUILT TOP ASSEMBLY

1. With right sides facing, join purple rectangles along long side to make 1 (60½") square for center of quilt top.

2. To make inner border, join 1½" x 61" green print strips along short ends. With wrong sides facing, fold border in half lengthwise; press. With raw edges aligned, pin inner border around edge of quilt, mitering corners, as shown in **Quilt Top Assembly Diagram.** Baste. Trim excess length.

3. To make outer borders, join 1 (6½" x 60½") gold print strip to top edge of quilt, stitching through all layers. Repeat for bottom edge of quilt. To make 1 side border, join 1 (6½" x 49¾") gold strip, 1 (6½") aqua square, and 1 (6½" x 17¼") gold strip along short edges as shown in photograph. Join border to 1 side of quilt, as shown in **Quilt Top Assembly Diagram,** stitching through all layers. Repeat for second side border.

4. To make green leaves A, B, and C, cut 4 As, 2 Bs, and 2 Cs from paper, muslin, or other foundation material. For As and Bs, string-piece assorted green prints randomly to foundation; trim along cutting line. For Cs, string-piece light green prints to half of leaf and dark green prints to remaining half. Trim along cutting line.

5. To make green/gold leaves A, cut and appliqué 1 (6") gold print

square to 1 string-pieced green A along placement lines indicated on pattern piece. Turn leaf over; trim excess green print from beneath gold square. Trim gold square along cutting line of A. Repeat to make 2 green/gold As.

6. To make 1 pieced leaf D, cut 1 (6") gold print and 1 (6") dark green print square. With right sides facing, stitch squares together. Press seam to 1 side. Aligning seam with placement line indicated on pattern piece, cut 1 green/gold pieced leaf D. Repeat to make 3 green/gold pieced Ds. In same fashion, make 1 aqua/green and 2 red/green pieced Ds. Set pieced leaves aside.

7. From gold, cut 1 irregular piece freehand, about 6" square. In same manner, cut 1 "square" from green, 5 from red, 8 from magenta, 4 from light purple, and 13 from aqua. Also from aqua, cut 2 pieces about 9" square. Referring to **Appliqué Placement Diagram** for position and to photograph for color placement, appliqué each to central panel in deliberately uneven rows, with 9" aqua "squares" at upper left and lower right. Appliqué leaves and stems to quilt. Align seams of green/gold As with edges of 9" aqua "squares" as shown in photograph.

QUILTING
Quilt in-the-ditch around all pieces. Quilt veins in leaves. Quilt purple inner quilt in 6" squares and in 1" chevron pattern as shown in photograph. Quilt vine in gold border.

FINISHED EDGES
Bind with bias binding made from gold print.

Quilt Top Assembly Diagram

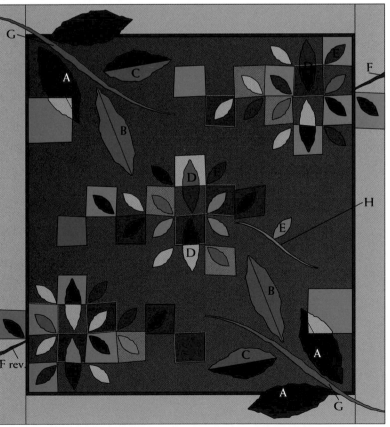

Appliqué Placement Diagram

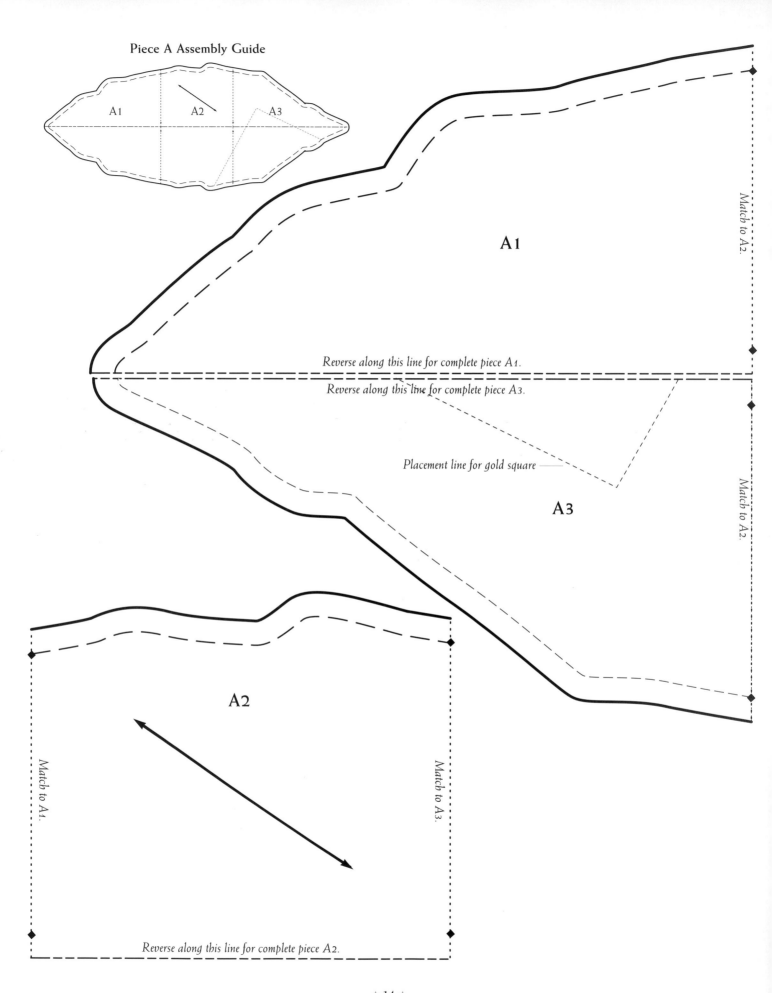

Piece A Assembly Guide

A1

A2

A3

A1

Reverse along this line for complete piece A1.

Reverse along this line for complete piece A3.

Placement line for gold square

A3

Match to A2.

Match to A2.

A2

Match to A1.

Match to A3.

Reverse along this line for complete piece A2.

Piece B Assembly Guide

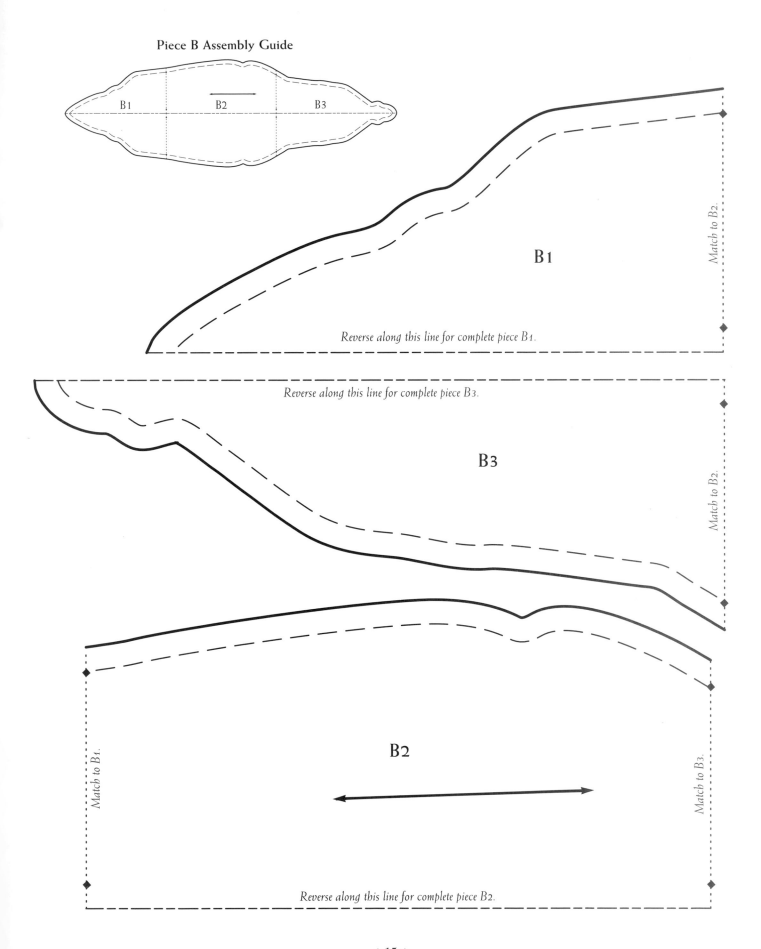

B1 B2 B3

B1

Match to B2.

Reverse along this line for complete piece B1.

Reverse along this line for complete piece B3.

B3

Match to B2.

B2

Match to B1.

Match to B3.

Reverse along this line for complete piece B2.

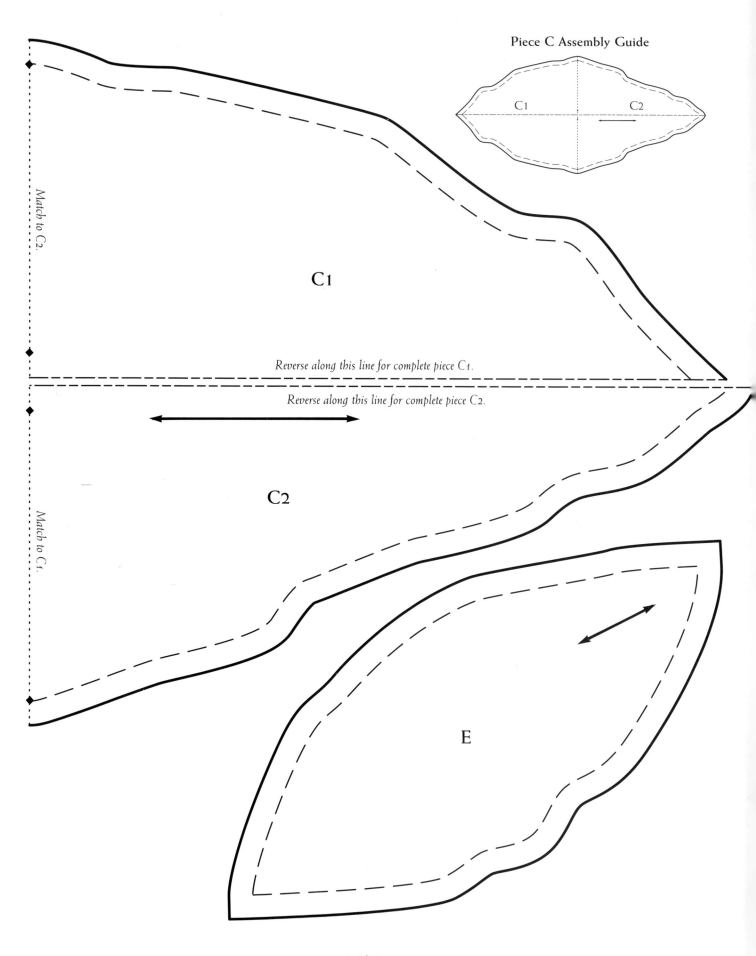

Piece C Assembly Guide

C1

C2

Match to C2.

Match to C1.

Reverse along this line for complete piece C1.

Reverse along this line for complete piece C2.

E

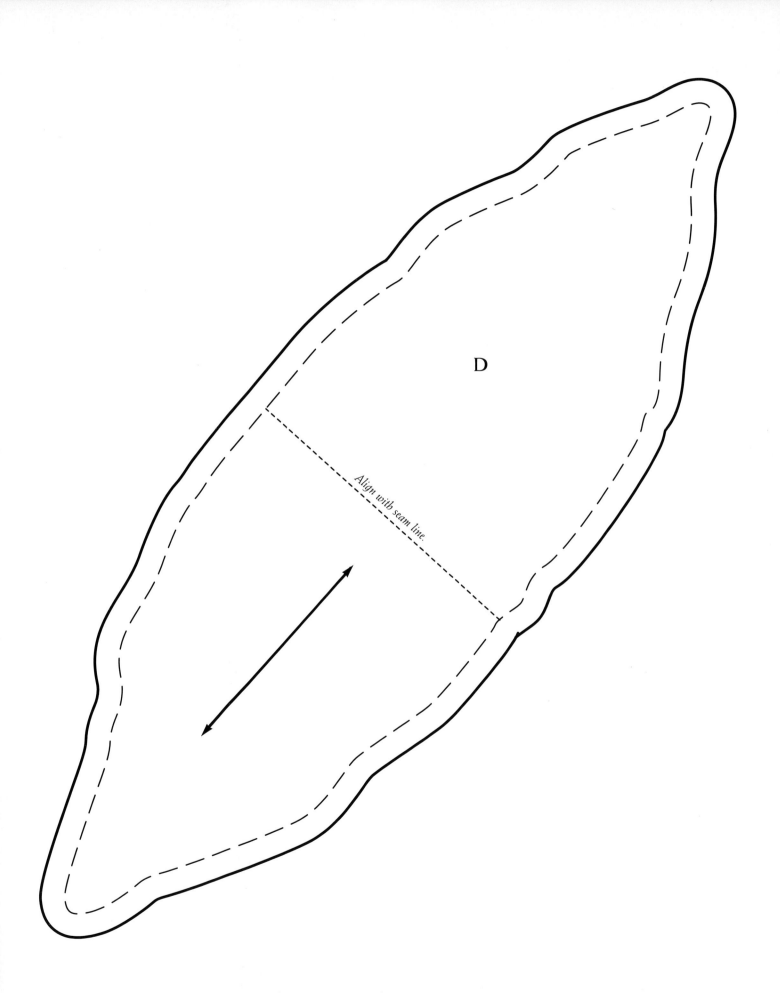

D

Align with seam line.

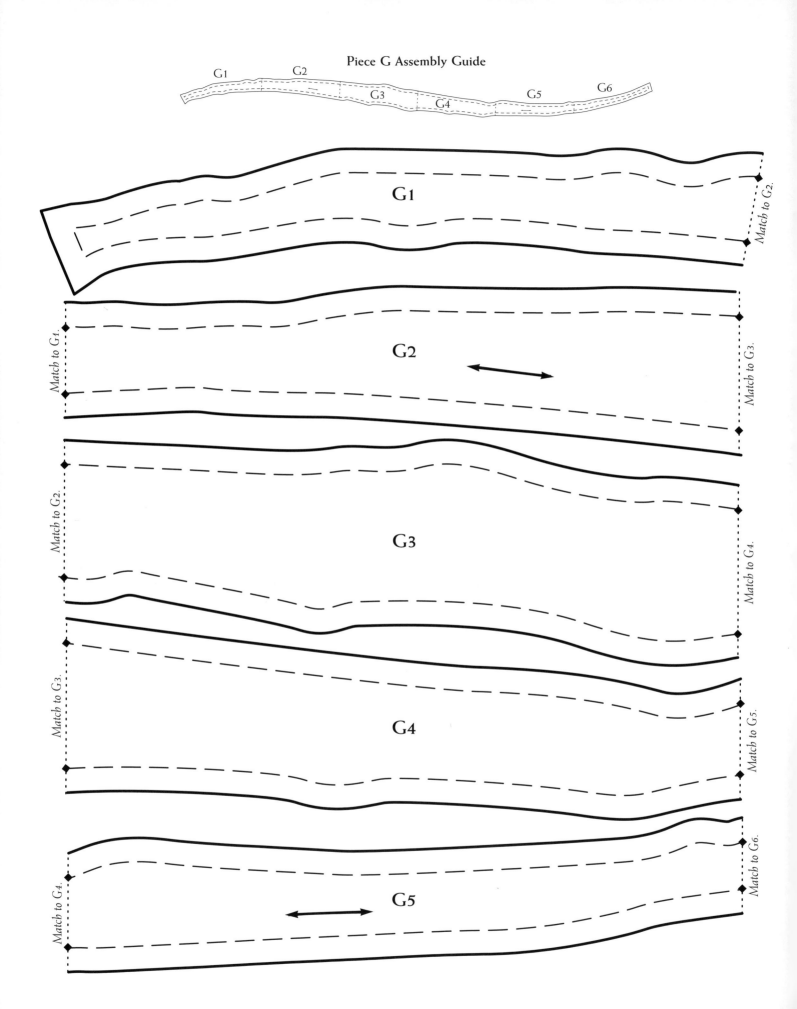

Piece G Assembly Guide

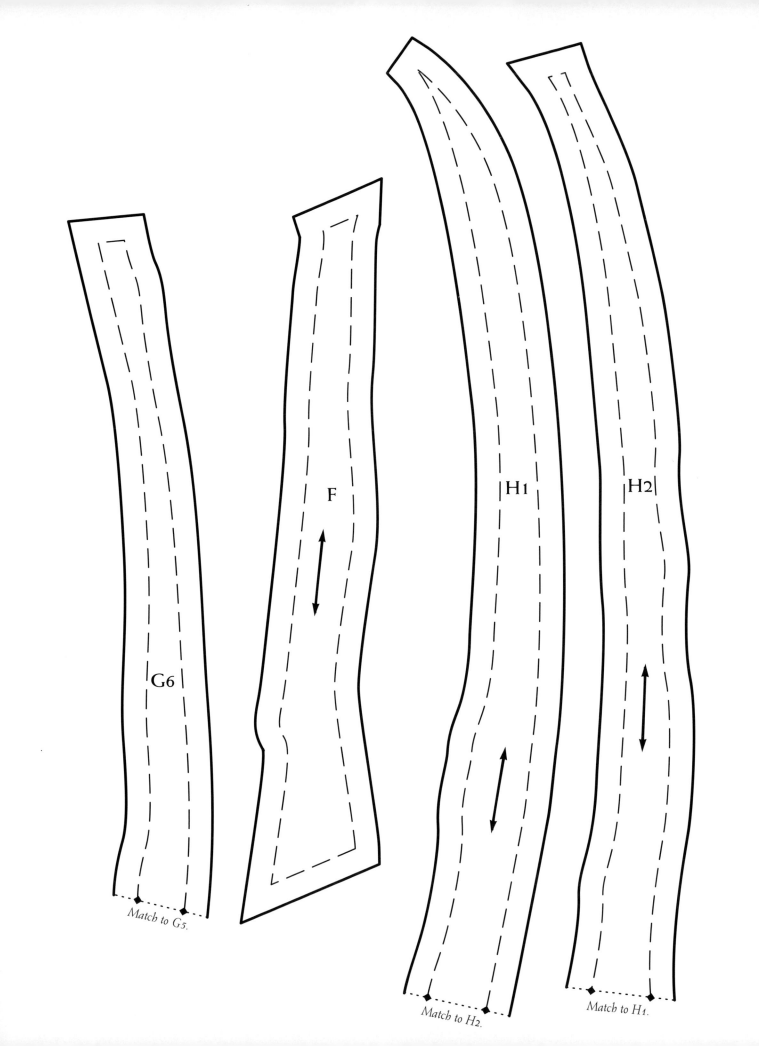

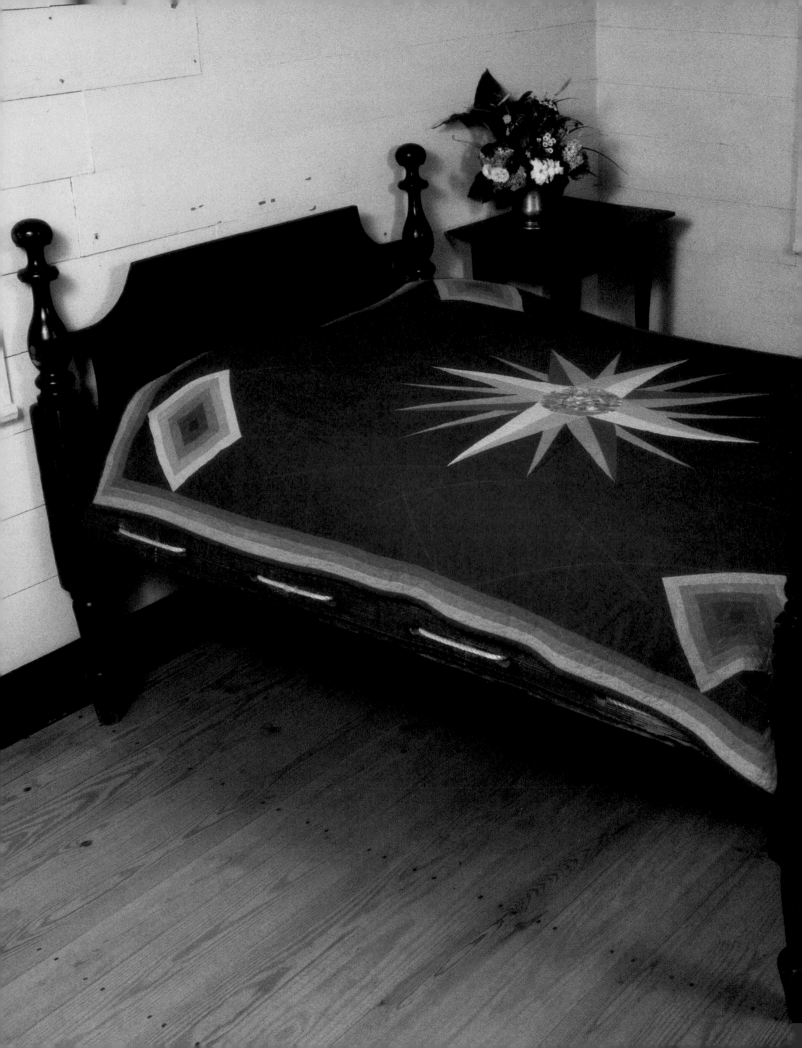

Tick TOCK

*L*ike many women of her generation, Deirdre Greer of Columbus, Georgia, learned to quilt as a young adult. "My grandmother taught me to quilt about 10 years ago," Deirdre says, "not long before my children were born. Before then, I had other interests."

But in those 10 years, quilting has become an important part of Deirdre's life. When she learned about the Gift of Quilts being organized by the Georgia Quilt Project, she immediately began planning her contribution.

The log cabin blocks in the four corners of her quilt, pictured at left, represent the four corners of the world. "The Mariner's Compass in the center is a humorous reference to my home town of Columbus," Deirdre says. "It also symbolizes America's reaching out to the world and the coming together of all countries at the Olympic Games."

Although Deirdre gives away most of her quilts, her husband was reluctant to let *Tick Tock* go. "He enjoys my quilts," she says, "but he usually doesn't get attached to them! I've promised to make another one that he can keep."

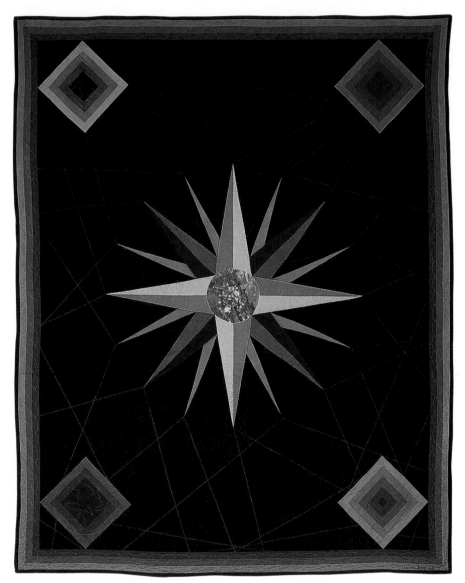

Tick TOCK

FINISHED QUILT SIZE
58" x 74½"

FABRIC REQUIREMENTS

Dark blue	4½ yards*
Medium blue	⅛ yard
Gold	¼ yard
Dark gold	¼ yard
Green #1**	⅜ yard
Green #2**	⅛ yard
Green #3**	⅛ yard
Green #4**	⅛ yard
Green #5**	⅜ yard
Magenta #1**	⅜ yard
Magenta #2**	⅛ yard
Magenta #3**	⅛ yard
Magenta #4**	⅛ yard
Magenta #5**	⅜ yard
Orange #1**	⅛ yard
Orange #2**	⅛ yard
Orange #3**	⅛ yard
Orange #4**	⅛ yard
Orange #5**	⅛ yard
Blue #1**	⅛ yard
Blue #2**	⅛ yard
Blue #3**	⅛ yard
Blue #4**	⅛ yard
Blue #5**	⅛ yard
Slate blue #1**	2⅛ yards***
Slate blue #2**	2⅛ yards***
Slate blue #3**	2⅛ yards***
Backing	4½ yards

*Includes ¾ yard for bias binding.
**Gradated solids are numbered from darkest (#1) to lightest (#5). For mail-order sources, see page 23.
***Required to cut borders in 1 length-wise strip. To save fabric, buy ⅜ yard of each color; cut 1" cross-wise strips and piece as needed to form borders.

PIECES TO CUT

Dark blue
★ 4 (22" x 26½") rectangles
★ 2 (13¼" x 27") rectangles
★ 8 (7¼") squares†
★ 16 B

Medium blue
★ 4 E

Gold
★ 4 D rev.

Dark gold
★ 4 D

Green #1
★ 8 A

Green #5
★ 8 A rev.

Magenta #1
★ 4 C

Magenta #5
★ 4 C rev.

Slate blue #1
★ 2 (1½" x 59½") inner border strips
★ 2 (1½" x 76½") inner border strips

Slate blue #2
* 2 (1½" x 59½") middle border strips
* 2 (1½" x 76½") middle border strips

Slate blue #3
* 2 (1½" x 59½") outer border strips
* 2 (1½" x 76½") outer border strips

†Cut each square in half diagonally for 16 corner triangles.

QUILT TOP ASSEMBLY

1. Referring to **Center Block Assembly Diagram**, join 2 green #1 As, 2 green #5 A revs., 2 dark blue Bs, 1 magenta #1 C, 1 magenta #5 C rev., 1 gold D, and 1 dark gold D rev. as shown. Join 1 E to inner curve of pieced section. Appliqué pieced section to corner of 1 (22" x 26½") dark blue rectangle to make ¼ of center block. Turn to wrong side; trim excess from beneath pieced section. In same fashion, make remaining quarters. Join quarters to complete center block.

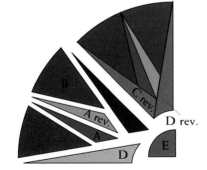

Center Block Assembly Diagram

2. To make 1 Courthouse Steps block, cut 1 (2⁵⁄₁₆") square from green #1. From greens #2-#5, cut 1 (2⁵⁄₁₆") crosswise strip of each color. Referring to **Courthouse Steps Block Assembly Diagram**, join strips to center square in order,

darkest to lightest. (Finished size should be 9½" square.) Join 1 dark blue corner triangle to each side of pieced square to make 1 Courthouse Steps block. In same fashion, cut strips and make Courthouse Steps blocks of magenta, orange, and blue.

Figure 1 Figure 2

Figure 3

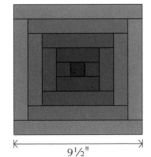

|← 9½" →|

Figure 4

Courthouse Steps Block Assembly Diagram

3. Join green and orange Courthouse Steps block to short ends of 1 (13¼" x 27") dark blue rectangle. Join to top of center block. Repeat, using magenta and blue blocks, for bottom of quilt.
4. To make 1 side border, join 1 (1½" x 76½") slate blue #1 inner border strip, 1 (1½" x 76½") slate blue #2 middle border strip, and 1 (1½" x 76½") slate blue #3 outer border strip along long edges. Join to 1 side of quilt with darkest strip

innermost. Repeat for second side border. In same fashion, join remaining border strips to make top and bottom borders. Join to top and bottom of quilt, mitering corners.

QUILTING
Quilt in-the-ditch around all pieces, or quilt as desired.

FINISHED EDGES
Bind with bias binding made from dark blue.

SOURCES

Mail-order sources for gradated fabrics:

Lunn Fabrics
357 Santa Fe Drive
Denver, CO 80223
(303) 623-2710
Hand-dyed, hand-painted, and silk-screened fabric. Catalog $10 + $3 s&h; $10 refundable on first order.

Shades, Inc.
585 Cobb Parkway South
The Nunn Complex, Suite O
Marietta, GA 30062

Match to C2.

C1

E

Match to B2.

Match to B1.

B1

A1

B2

Reverse along this line for complete piece B.

See Piece B Assembly Guide on page 25.

Match to A2.

Match to C1.

C2

Piece B
Assembly Guide

B1 B2

D2

A2

D1

Match to A1.

Match to D1.

Match to D2.

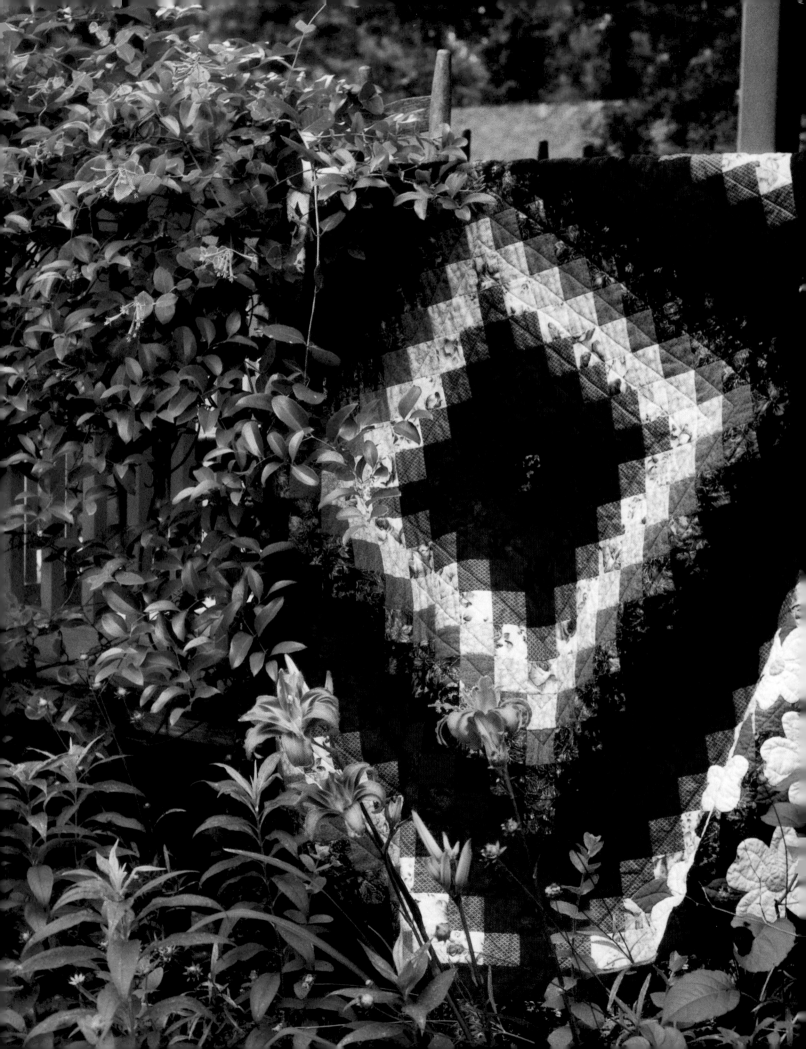

Dogwoods Around the WORLD

"*T*he gift of quilts is a unique opportunity—something that's never been done before," says Kathleen Hefner of Stone Mountain. "When the call for quilts came out, I just knew I had to be part of it."

Kathy chose her basic pattern, Trip Around the World, to symbolize the path her gift quilt might take. After choosing the blue and dark red prints, she realized that if she also added white, the colors would symbolize the country from which the gift came.

"Dogwoods mean Atlanta to me,"says Kathy. "So I used a dogwood pattern I designed for an earlier gift, a commemorative quilt for a member of my church." With help from her husband, Kathy arranged the dogwood blossoms across the pieced top and machine-appliquéd them into place.

"By making this quilt," Kathy says, "I too have become part of the fabric of the Olympic games. It may go around the world or it may go across the country—it doesn't matter. It's going to another person, and that's what quilts are for. They're for people."

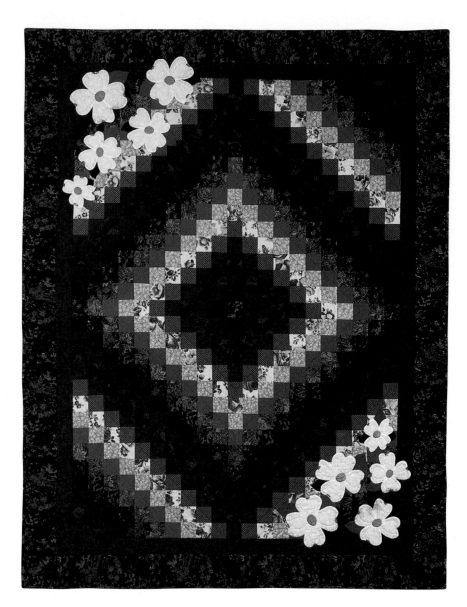

Dogwoods Around the WORLD

OTHER MATERIALS
Brown permanent pen

PIECES TO CUT
Blue print #1
★ 62 A
Blue print #2
★ 2 (5½" x 74") outer border strips
★ 2 (5½" x 58") outer border strips
★ 61 A
Blue print #3
★ 60 A
Blue print #4
★ 60 A
Blue print #5
★ 60 A
Burgundy print #1
★ 62 A
Burgundy print #2
★ 62 A
Burgundy print #3
★ 2 (2½" x 48") inner border strips
★ 2 (2½" x 64") inner border strips
★ 62 A
Burgundy print #4
★ 60 A
Burgundy print #5
★ 60 A
White
★ 12 B
★ 16 E
★ 12 H
Green
★ 8 D
★ 8 G
★ 6 J
Gold
★ 3 C
★ 4 F
★ 3 I

FINISHED QUILT SIZE
56" x 72"

FABRIC REQUIREMENTS

Blue print #1*	⅜ yard
Blue print #2*	3 yards**
Blue print #3*	⅜ yard
Blue print #4*	⅜ yard
Blue print #5*	⅜ yard
Burgundy print #1*	⅜ yard
Burgundy print #2**	⅜ yard
Burgundy print #3**	3 yards
Burgundy print #4*	⅜ yard
Burgundy print #5*	⅜ yard
White	¼ yard
Green	¼ yard
Gold	⅛ yard
Backing	4½ yards

*Prints are numbered from darkest (#1) to lightest (#5).

**Includes ¾ yard for bias binding.

QUILT TOP ASSEMBLY

1. Referring to **Quilt Top Assembly Diagram** and to photograph for color placement, join blue and burgundy As in 29 horizontal rows of 21 each. Join rows.

2. Join 2½" x 64" burgundy inner border strips to sides of quilt. Join 2½" x 48" burgundy inner border strips to top and bottom of quilt, mitering corners.

3. Join 5½" x 74" blue outer border strips to sides of quilt. Join 5½" x 58" blue outer border strips to top and bottom of quilt, mitering corners.

4. Referring to **Appliqué Placement Diagram** on page 30 for placement, appliqué 3 Ds, 4 Bs, and 1 C to quilt as shown to make 1 small dogwood flower. Repeat. To make third small dogwood flower, appliqué 2 Ds, 4 Bs, and 1 C to quilt as shown. In same fashion, appliqué 2 Gs, 4 Es, and 1 F to make 1 medium dogwood flower; appliqué 2 Js, 4 Hs, and 1 I to make 1 large dogwood flower. Repeat to make 4 medium and 3 large flowers.

5. To complete dogwood flowers, use brown permanent pen to mark ends of petals as shown on pattern pieces.

QUILTING

Quilt ¼" inside edges of dogwood petals. Quilt around centers of flowers. Quilt lines radiating from centers of flowers toward edges of petals. Quilt remainder in diagonal lines as shown in photograph, or quilt as desired.

FINISHED EDGES

Bind with bias binding made from blue print #2.

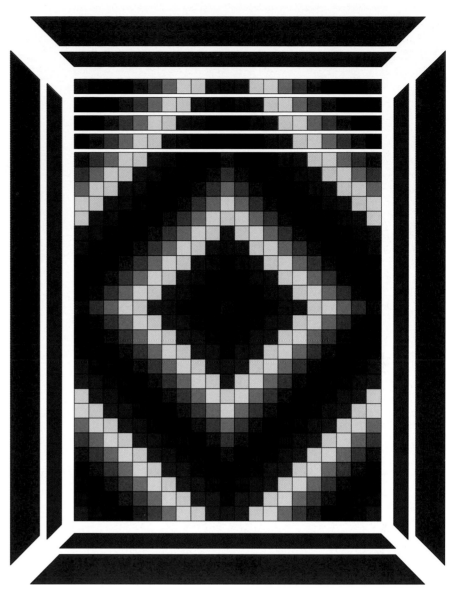

Quilt Top Assembly Diagram

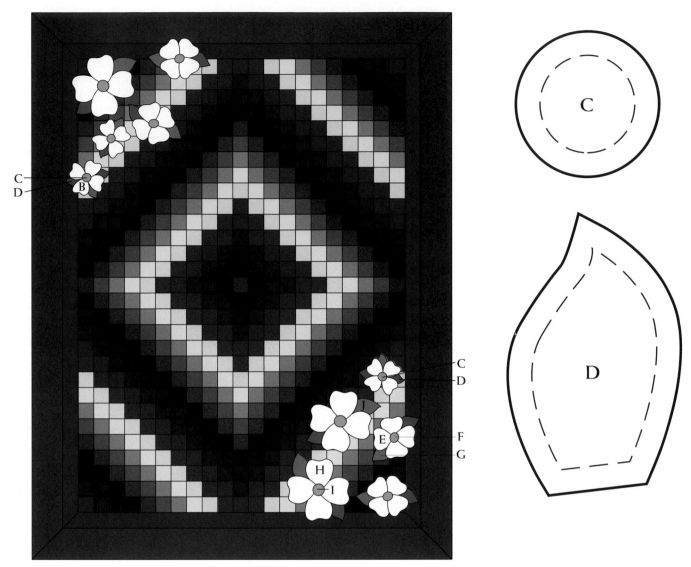

Appliqué Placement Diagram

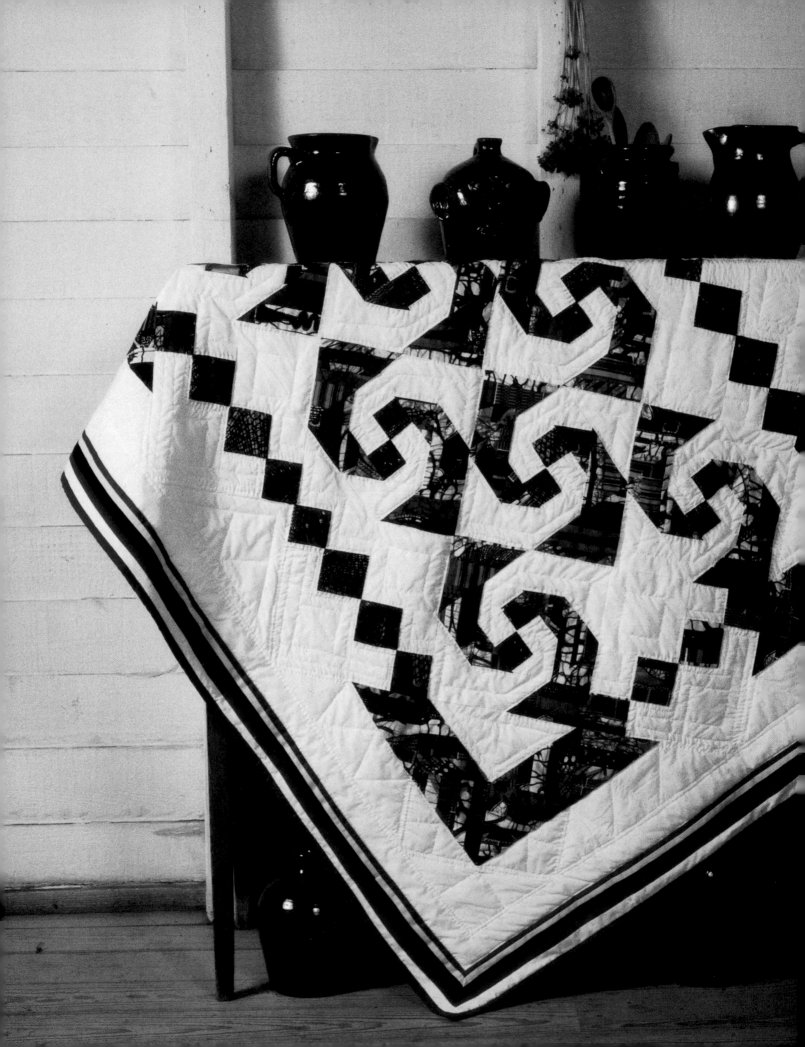

Photography on these pages courtesy of Tullie Smith Farm at the Atlanta History Center, by William F. Hull.

Simply...
CONGRATULATIONS

*H*uisha Kiongozi (Hoo-EE-sha Kee-on-GO-zee) of Atlanta grew up with quilts, learning to sew from her mother, an excellent seamstress. "She taught us to crochet and knit," Huisha says, "but I didn't learn to quilt until a friend taught me several years ago. Once I learned, I was hooked."

Approached by a member of the Georgia Quilt Project at a documentation day in 1993, Huisha readily agreed to make a gift quilt for the Olympic Games. She chose fabrics from her wonderful collection of African textiles, bought a few new pieces in brighter colors specifically for this quilt, and made blocks using the simple traditional Double Four-Patch and Snail's Trail patterns. "Then I just moved them around until I found an arrangement I liked," she says. "It's such a simple quilt that I gave it a simple name as well."

Huisha is happy and honored to have her quilt included in the Olympic Games gift of quilts. "I'm just excited that it's going to some athlete, somewhere," she says. "And it carries with it all that I'd like to say to the Olympians: Simply...congratulations."

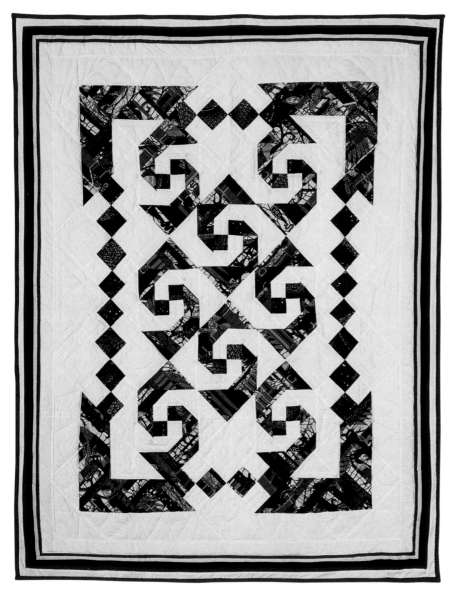

Simply...CONGRATULATIONS

FINISHED QUILT SIZE
59½" x 73½"

FABRIC REQUIREMENTS
White	3½ yards*
African print	1¼ yards
Blue	2 yards**
Gold	2 yards**
Black	2 yards**
Green	2 yards**
Red	2 yards**
Backing	4½ yards

*Includes ¾ yard for bias binding.
**Required to cut borders in 1 length-wise strip. To save fabric, buy ⅜ yard of each color; cut 1" cross-wise strips and piece as needed to form borders.

PIECES TO CUT

White
- ★ 2 (2½" x 58") inner border strips
- ★ 2 (2½" x 48") inner border strips
- ★ 2 (1½" x 63") outer border strips
- ★ 2 (1½" x 55") outer border strips
- ★ 1 (15⅜") square***
- ★ 2 (8") squares†
- ★ 28 (5⅞") squares††
- ★ 12 (5½") squares (B)
- ★ 24 (3") squares (C)
- ★ 4 (6¼") squares†††
- ★ 8 (3⅛") squares#
- ★ 16 (2¼") squares (F)

African print
- ★ 20 (5⅞") squares††
- ★ 24 (3") squares (C)
- ★ 4 (6¼") squares †††
- ★ 8 (3⅛") squares#
- ★ 16 (2¼") squares (F)

Blue
- ★ 2 (1" x 63") border strips
- ★ 2 (1" x 53") border strips

Gold
- ★ 2 (1" x 63") border strips
- ★ 2 (1" x 53") border strips

Black
- ★ 2 (1" x 63") border strips
- ★ 2 (1" x 53") border strips

Green
- ★ 2 (1" x 63") border strips
- ★ 2 (1" x 53") border strips

Red
- ★ 2 (1" x 63") border strips
- ★ 2 (1" x 53") border strips

***Cut into quarters diagonally for 2 side triangles. (You will have 2 left over.)
†Cut in half diagonally for 4 corner triangles.
††Cut each 5⅞" square in half diagonally for 2 As.
†††Cut each 6¼" square into quarters diagonally for 4 Ds.
#Cut each 3⅛" square in half diagonally for 2 Es.

QUILT TOP ASSEMBLY

1. Referring to **Block 1 Assembly Diagram**, join 4 white As and 4 African print As as shown to make 1 Block 1. Repeat to make 4.

Block 1 Assembly Diagram - *Make 4.*

2. Referring to **Block 2 Assembly Diagram**, join 2 white Bs, 4 white Cs, and 4 African print Cs as shown to make 1 Block 2. Repeat to make 6.

Block 2 Assembly Diagram - *Make 6.*

3. Referring to **Block 3 Assembly Diagram**, join 2 white As, 2 African print As, 2 white Ds, 2 African print Ds, 2 white Es, 2 African print Es, 2 white Fs, and 2 African print Fs as shown to make 1 Block 3. Repeat to make 8.

Block 3 Assembly Diagram - *Make 8.*

4. Referring to **Block 4 Assembly Diagram**, join 3 white As and 1 African print A as shown to make 1 Block 4. Repeat to make 8.

Block 4 Assembly Diagram - *Make 8.*

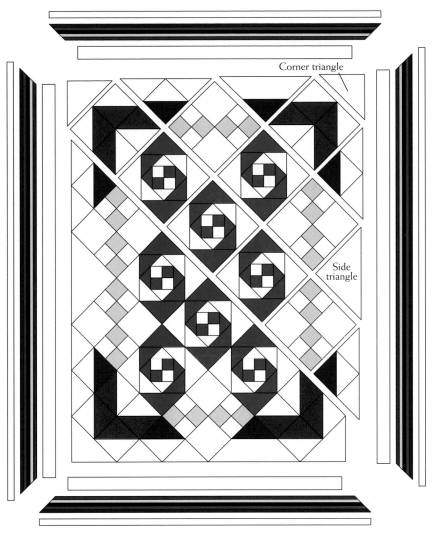

Quilt Top Assembly Diagram

5. Referring to **Quilt Top Assembly Diagram**, join blocks, side triangles, and corner triangles in diagonal rows as shown. Join rows.

6. Join 2½" x 58" white inner borders to sides of quilt. Join 2½" x 48" white inner borders to top and bottom of quilt, butting corners.

7. To make 1 side pieced border, join 1 (1" x 63") blue border strip, 1 (1" x 63") gold border strip, 1 (1" x 63") black border strip, 1 (1" x 63") green border strip, and 1 (1" x 63") red border strip along long edges. Join to 1 side of quilt with blue strip innermost. Repeat to make

and join remaining side pieced border. In same manner, make top and bottom pieced borders from remaining strips. Join to top and bottom of quilt, mitering corners.

8. Join 1½" x 63" white outer borders to sides of quilt. Join 1½" x 55" white outer borders to top and bottom of quilt, butting corners.

QUILTING

Quilt in-the-ditch around all pieces, or quilt as desired.

FINISHED EDGES

Bind with bias binding made from white.

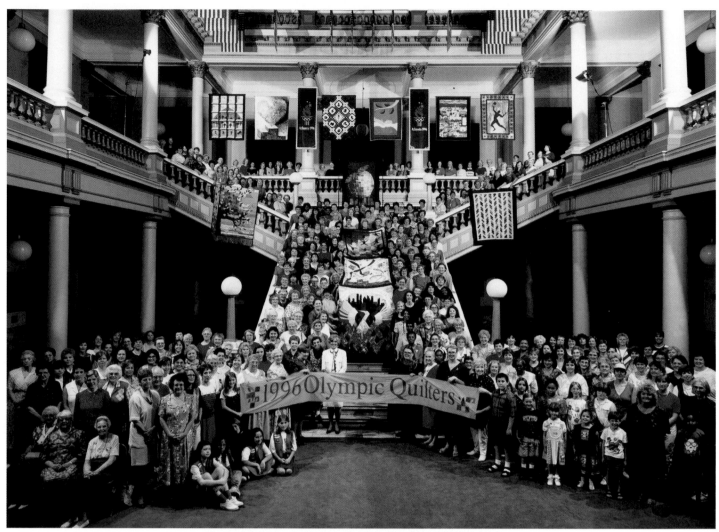

More than 300 of the dedicated Georgia Quilt Project volunteers gathered at the State Capitol in Atlanta in August 1995, for this group photograph.

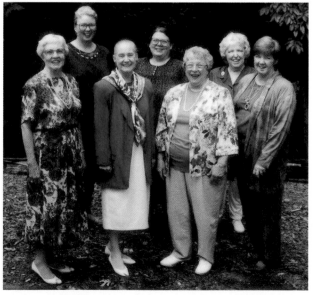

The Board of Directors of the Georgia Quilt Project. From left:
Carolyn Kyle, Margie Rogers, Nellie T. Giddens, Anita Zaleski
Weinraub (Chairwoman), Ann Gravelle, Mary Ross, and Holly
Anderson. Not shown: Liv Gronli, Patricia Phillips, and Elizabeth
Harris (Honorary Chairwoman).

The Gift of QUILTS

The Atlanta History Center and the Georgia Quilt Project first joined forces in 1990 to document some of the many quilts made throughout the history of the state of Georgia. During the next several years, our discussions began to include the new quilts being made to celebrate the 1996 Olympic Games, and we realized what a fantastic opportunity it would be to show all of the Olympic gift quilts at the Atlanta History Center. As the first gift quilts were completed and displayed at local quilt shows in 1993, the Quilt Project received enthusiastic response from viewers. We knew we could not miss the chance to show them all together, in the only complete exhibition before the Olympic Games.

As the quiltmaking effort continued, volunteers from local guilds held a quilting bee once a month at the History Center. A staff member of the History Center even joined the enthusiasm by pledging a gift quilt of her own. Despite her busy schedule, she finished her quilt just in time in July of 1995. By August 1, 1995, the Olympic Games gift quilts were completed.

All 397 gift quilts are on view together for the first and only time in this exhibit, titled *The Olympic Games Quilts: Georgia's Welcome to the World*, from January 20 to May 12, 1996. They are arranged alphabetically according to the country of receipt, beginning with Afghanistan and ending with Zimbabwe. Also on exhibit is the quilt symbolizing the "Look of the Games," *A Quilt of Leaves*. A map of the gallery space accompanies the exhibit to identify the quilt name, location, quiltmaker(s), and the receiving country.

Each quilt features this documentation label.

A large world map helps visitors discover exactly where each country is located. A quilting frame is set up in the gallery space for visitors to see how quilting is done and to try it themselves. Volunteers from the Georgia Quilt Project come in during the weekdays to demonstrate their skills and to teach visiting school groups about quilting.

The exhibition also provides a chance for visitors to learn about the 197 nations invited to the Olympic ceremonies. It provides a colorful and textural way for school children to learn about international geography. The exhibition is included in the 1996 school tour program run by the education department at the History Center. The History Center is pleased to be part of the unprecedented effort that led to the Olympic Games Gift of Quilts. As the history of the city of Atlanta and the state of Georgia continues to unfold, the Center will continue to record and celebrate the achievements of its citizens.

Elizabeth Weyburn
Curator of Costumes and Textiles
Atlanta History Center

The Olympic Games Quilts: Georgia's Welcome to the World
January 20-May 12, 1996
Atlanta History Center
130 West Paces Ferry Road
Atlanta, Georgia 30305
(404) 814-4000

Golden Dreams
Carolyn Kyle; Decatur, Georgia
Special Gift: Billy Payne, Atlanta Committee for the Olympic Games

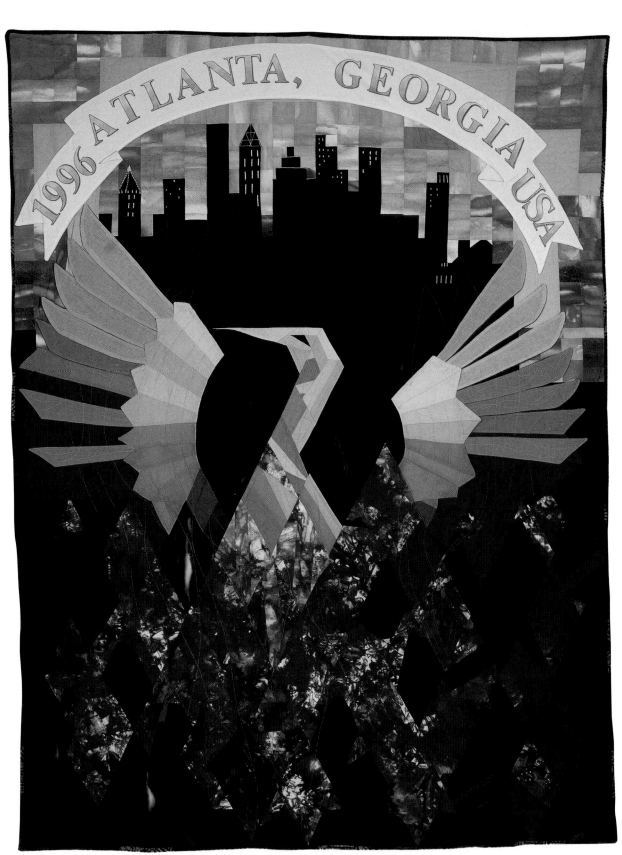

City of Gold
Barbara Hendrick Abrelat; Decatur, Georgia
Special Gift: Juan Antonio Samaranch for the Museé Olympique; Lausanne, Switzerland

Patchwork Windows
Lorraine Waddell; Highlands Ranch, Colorado
Afghanistan, *National Olympic Committee*

Olympic Blue Ribbon
Jackie Johnson; Cumming, Georgia
Afghanistan, *Flagbearer*

Timeless Reflections
Darlene Bandoly, Catherine Callahan, Laura Callahan,
and Lucille Patheal; Marietta, Georgia
Albania, *National Olympic Committee*

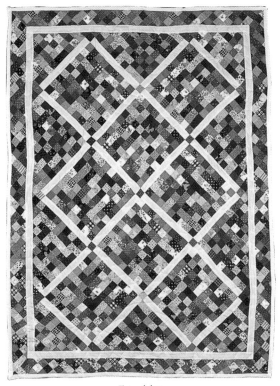

Friendship
Ollie Wright; Carrollton, Georgia
Albania, *Flagbearer*

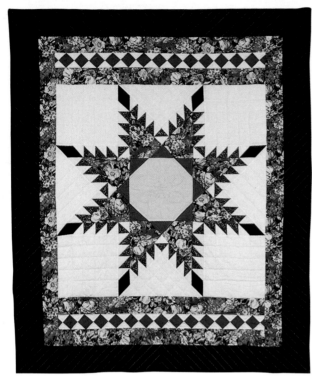

Feathered Star II
Joan Campitelli; Alpharetta, Georgia
Algeria, *National Olympic Committee*

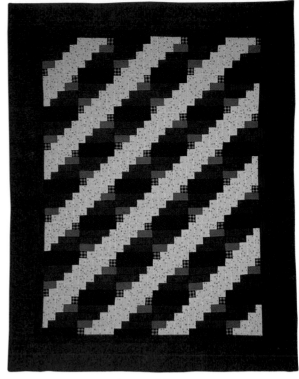

Stars and Stripes
Carolyn McGinness; Blue Ridge, Georgia
Algeria, *Flagbearer*

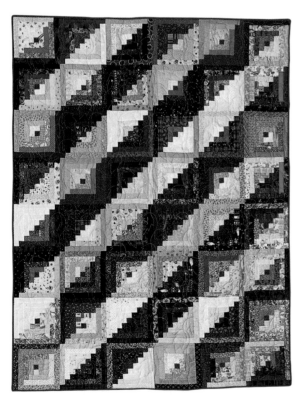

Scrap Log Cabin
Village Quilt Shop; Stone Mountain, Georgia
American Samoa, *National Olympic Committee*

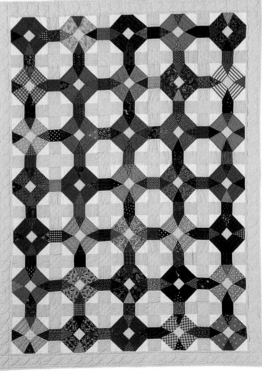

Linking Arms of Friendship
Teri Crane; Marietta, Georgia
American Samoa, *Flagbearer*

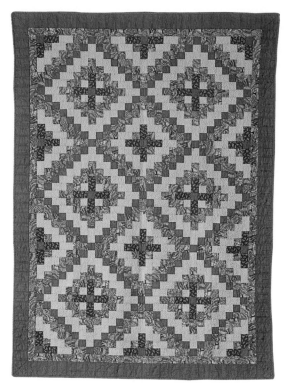

Southern Comfort
Peggy Littrell and Helen Gene Eberhart,
Stone Mountain, Georgia
Andorra, *National Olympic Committee*

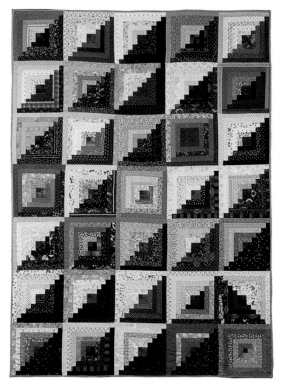

Log Cabin
Carolyn Settle, Winder, Georgia
Andorra, *Flagbearer*

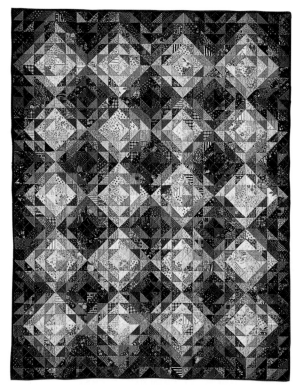

1,768 Triangles
Merle Schmidt, Snellville, Georgia
Angola, *National Olympic Committee*

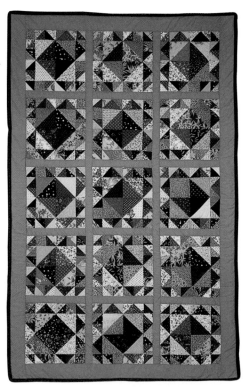

Tricky Triangles
Janette Smith, Lizella, Georgia
Angola, *Flagbearer*

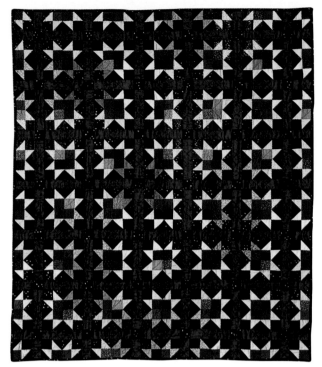

Atlanta Stars
Libby Carter, Sandy Espenschied, and Quiltsitters
Circle of Dream Quilters; Tucker, Georgia
Antigua and Barbuda, *National Olympic Committee*

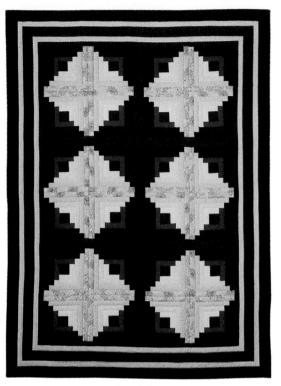

Log Cabin
Dorothy Randall; Monroe, Georgia
Antigua and Barbuda, *Flagbearer*

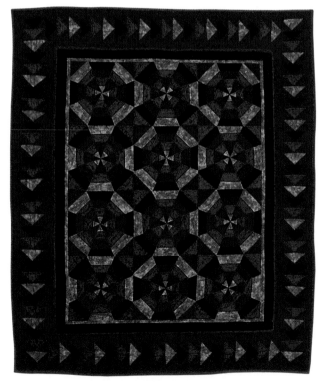

Kaleidoscope
Carole Thomas; Tucker, Georgia
Argentina, *National Olympic Committee*

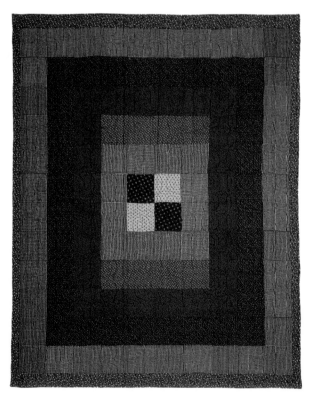

Homespun
Whit Robbins; Atlanta, Georgia
Argentina, *Flagbearer*

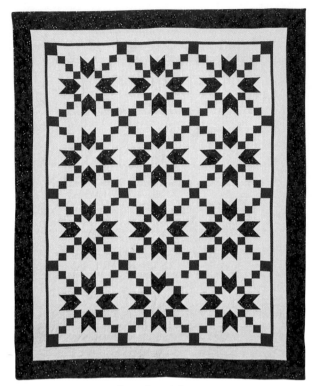

Stars from Atlanta
Alice Hix; Lithonia, Georgia
Armenia, *National Olympic Committee*

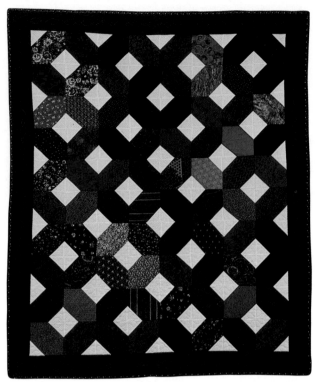

Friendship Rings
Cumming Sunset Quilters; Cumming, Georgia
Armenia, *Flagbearer*

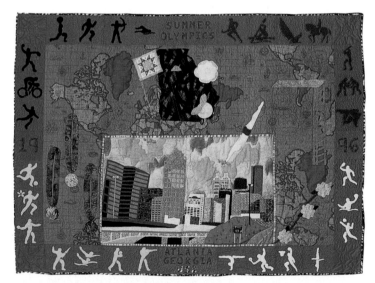

Dive Into Atlanta
Lynne Whitener; Conyers, Georgia
Aruba, *National Olympic Committee*

Friendship Chain
Dorothy L. Bovard and Sammie Simpson;
Atlanta, Georgia
Aruba, *Flagbearer*

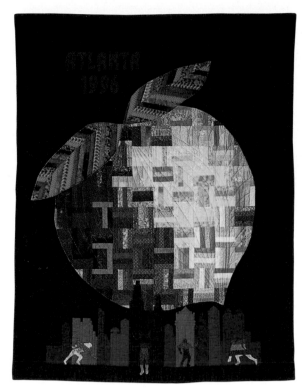

Georgia on My Mind
Margaret Jenkins; North Augusta, South Carolina
Australia, *National Olympic Committee*

Quilt Trip Around the World
Ruth Ackerman; Covington, Georgia
Australia, *Flagbearer*

A Gold Star for Atlanta
Fran M. Burns; Macon, Georgia
Austria, *National Olympic Committee*

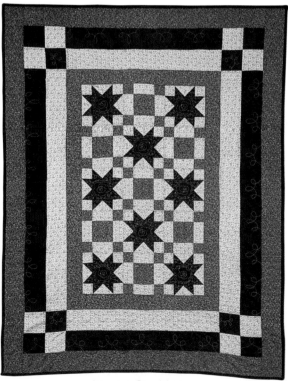

Morning Star Mystery
Wanda J. Hickman; Atlanta, Georgia
Austria, *Flagbearer*

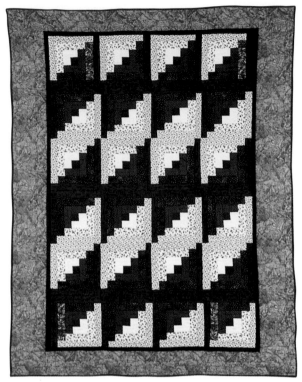

Georgia Log Cabin with Olympic Slant
Hazel A. Dunbar; Warner Robins, Georgia
Azerbaijan, *National Olympic Committee*

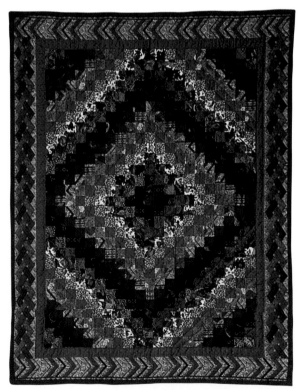

Attic Windows
Barbara Mathis; Moreland, Georgia
Azerbaijan, *Flagbearer*

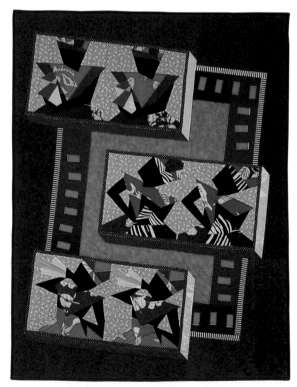

A Little Street Music
Jul Kamen; Nassau, Bahamas
Bahamas, *National Olympic Committee*

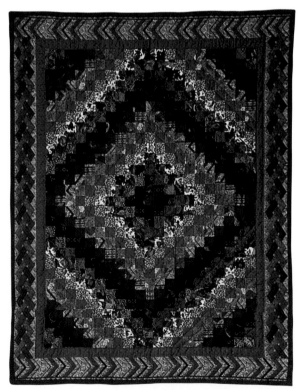

Trip Around the World
Michelle Hiskey; Atlanta, Georgia
Bahamas, *Flagbearer*

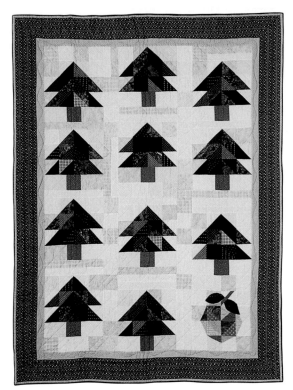

Peaches & Pines
Nancy Corey; Marietta, Georgia
Bahrain, *National Olympic Committee*

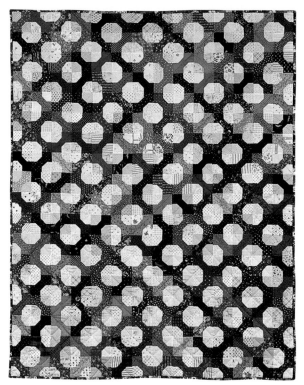

Ties Around the World
Paula Hammer; Lilburn, Georgia
Bahrain, *Flagbearer*

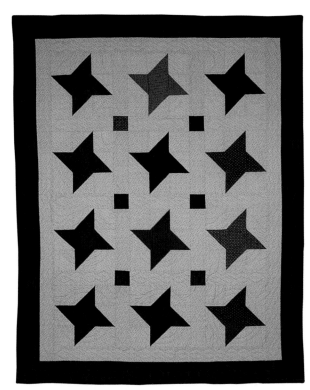

Stars All Around
Mary Frankiewicz; Snellville, Georgia
Bangladesh, *National Olympic Committee*

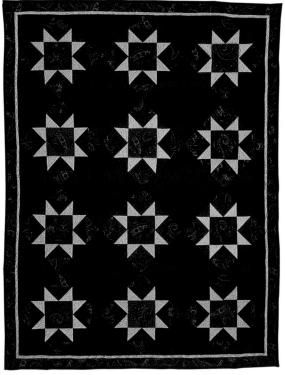

Georgia Pine Welcomes the World
Georgia Pine Quilt Guild; Concord, Georgia
Bangladesh, *Flagbearer*

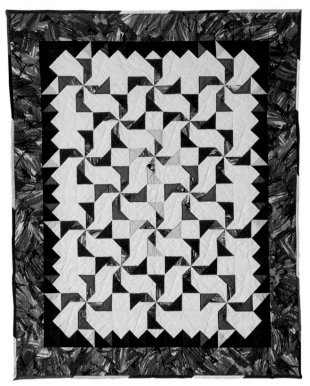

See Saw
Jean Phillips; College Park, Georgia
Barbados, *National Olympic Committee*

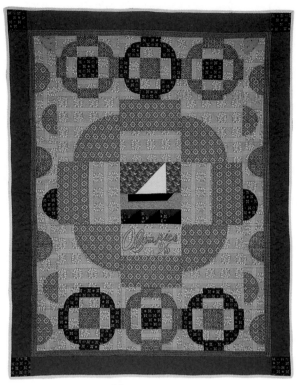

Olympics 1996 #2
Ronnie Durrence; Savannah, Georgia
Barbados, *Flagbearer*

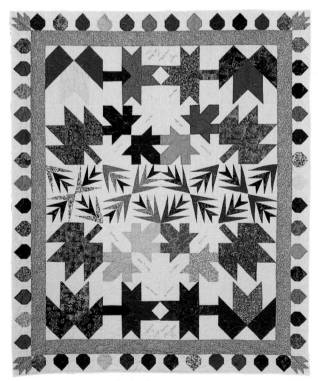

Quilt of Many Leaves
Quilting Adventures; Lilburn, Georgia
Belarus, *National Olympic Committee*

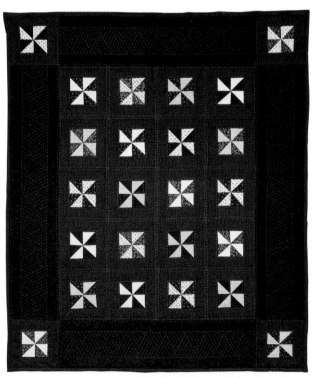

Play Time
Fay Anderson; Brunswick, Georgia
Belarus, *Flagbearer*

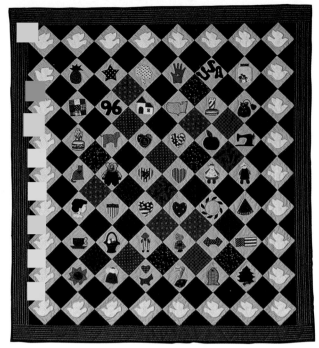

I Love Americana
Barbara Rogers; Stone Mountain, Georgia
Belgium, *National Olympic Committee*

Red Top Signature Quilt #3
Allatoona Quilt Guild; Acworth, Georgia
Belgium, *Flagbearer*

Georgia Pines and Kudzu Vines
Eloise Johansen; Macon, Georgia
Belize, *National Olympic Committee*

Star Struck
Gloria M. Severit; Roswell, Georgia
Belize, *Flagbearer*

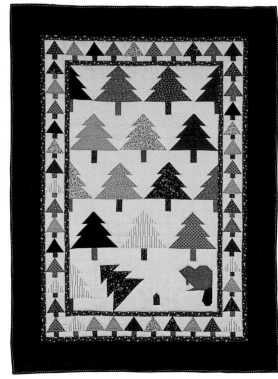

Eager Beaver
Lorraine Dusenbury, Judy Roehm, and Lyn Wylder;
Atlanta, Georgia
Benin, *National Olympic Committee*

A View from the Great Green Room
Janet Mooney; Winder, Georgia
Benin, *Flagbearer*

Olympic Stars in Georgia
Carol Maddox; Stone Mountain, Georgia
Bermuda, *National Olympic Committee*

With a Little Help from my Friends
Carole Helper; Macon, Georgia
Bermuda, *Flagbearer*

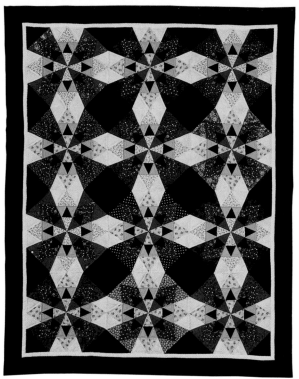

Act Well Your Part
Carolyn Singletary Craig; Warner Robins, Georgia
Bhutan, *National Olympic Committee*

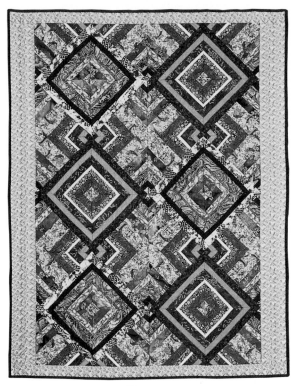

Happiness
Deborah Weeks; Macon, Georgia
Bhutan, *Flagbearer*

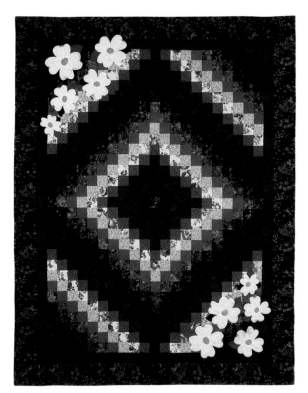

Dogwoods Around the World
Kathleen Hefner; Stone Mountain, Georgia
Bolivia, *National Olympic Committee*

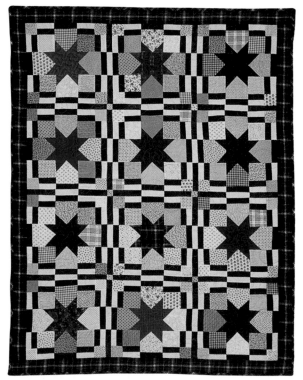

Old Glory
Roxanne Ivins; Stone Mountain, Georgia
Bolivia, *Flagbearer*

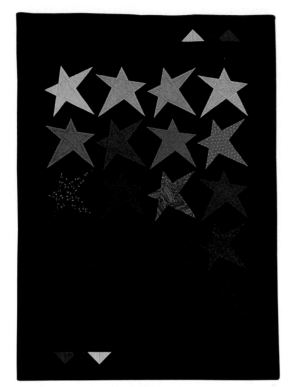

Reach for the Stars
Joan Cady; Marietta, Georgia
Bosnia and Herzegovina, *National Olympic Committee*

Crossroads of Georgia
Piecemakers–Heart of Georgia Quilt Guild;
Warner Robins, Georgia
Bosnia and Herzegovina, *Flagbearer*

Friendship Ribbons
Ille Waters; North Augusta, South Carolina
Botswana, *National Olympic Committee*

Olympic Charm Quilt
Kelly Posey; Atlanta, Georgia
Botswana, *Flagbearer*

Olympic Friendship
Jessie McCoy; Decatur, Georgia
Brazil, *National Olympic Committee*

Sunbonnet Sue
Ann Roberts; Cumming, Georgia
Brazil, *Flagbearer*

Indians Walked These Paths
Sue Sinkule; Seale, Alabama
British Virgin Islands, *National Olympic Committee*

Maple Leaf
LaVonne Childers; Cairo, Georgia
British Virgin Islands, *Flagbearer*

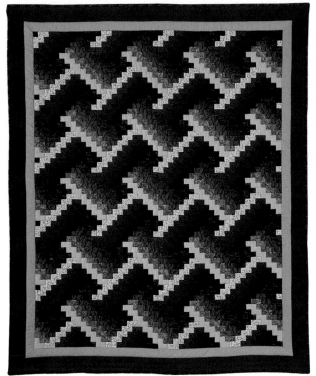

Winning Ribbons
Cathy Skrypek and Jane Grayson; Cumming, Georgia
Brunei Darussalam, *National Olympic Committee*

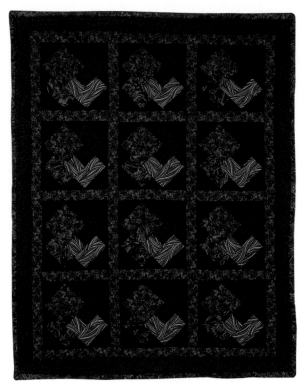

Winning Hands
Bettie Smith; Cumming, Georgia
Brunei Darussalam, *Flagbearer*

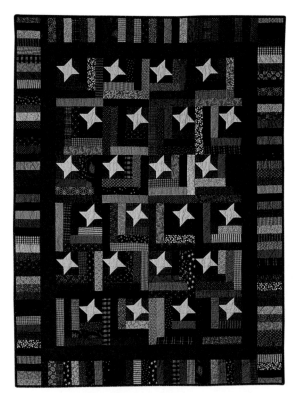

Gather the Stars
Pamela Cardone; Stone Mountain, Georgia
Bulgaria, *National Olympic Committee*

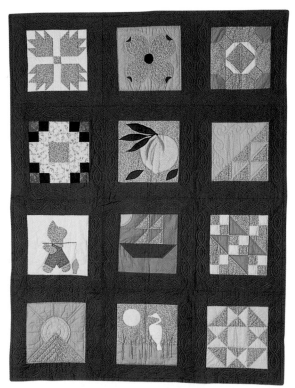

Georgia Sampler Quilt
Camden County Quilt Guild; St. Marys, Georgia
Bulgaria, *Flagbearer*

Sisters' Choice
Hilton Head Runaway Gang; Tucker, Georgia
Burkina Faso, *National Olympic Committee*

Nine Patch Plaid
Sarah Ridgeway; Atlanta, Georgia
Burkina Faso, *Flagbearer*

Village Square
Marilyn Murdock; Kansas City, Missouri
Burundi, *National Olympic Committee*

Around the Twist
Shirley Young; Conley, Georgia
Burundi, *Flagbearer*

Celtic
Karen Thomas; Douglasville, Georgia
Cambodia, *National Olympic Committee*

Mary's Triangle
Margaret Stent, Gale Probst, Betty Wolfram, and
Nancy Weatherly; Stone Mountain, Georgia
Cambodia, *Flagbearer*

Kaleidoscope
Carole Doyle; Stone Mountain, Georgia
Cameroon, *National Olympic Committee*

Olympic Stars Over Georgia
Susan Baker; Clarkston, Georgia
Cameroon, *Flagbearer*

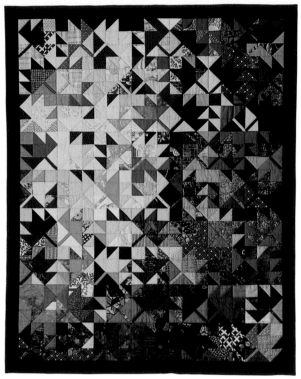

Seasons
Bonnie Finne; Atlanta, Georgia
Canada, *National Olympic Committee*

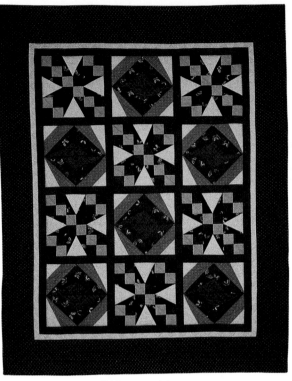

Welcome to Atlanta
Mary Ross; Griffin, Georgia
Canada, *Flagbearer*

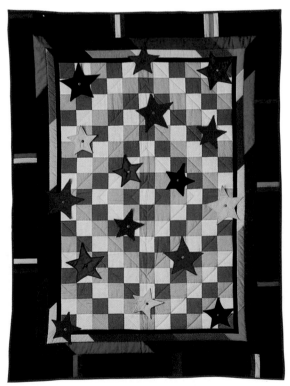

Stars Around the World
Audrey Keppler; Roswell, Georgia
Cape Verde, *National Olympic Committee*

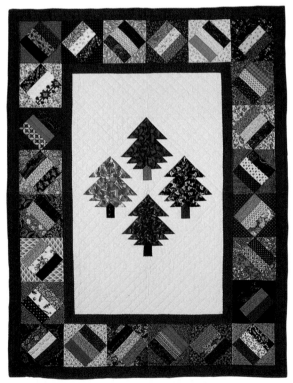

Autumn on the Withlacoochee
Withlacoochee Quilters' Guild; Valdosta, Georgia
Cape Verde, *Flagbearer*

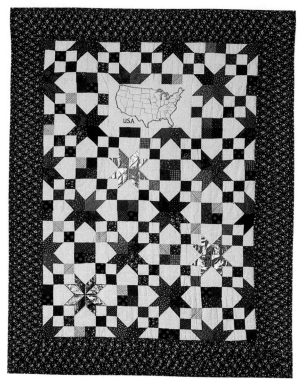

Stars Over Georgia
Quilters Guild of Harris County; Hamilton, Georgia
Cayman Islands, *National Olympic Committee*

Sailboats
Sue McCranie; Willacoochee, Georgia
Cayman Islands, *Flagbearer*

My State Georgia
Edna Picklesimer; Lizella, Georgia
Central African Republic, *National Olympic Committee*

Spools in Time
Hilton Head Runaway Gang; Tucker Georgia
Central African Republic, *Flagbearer*

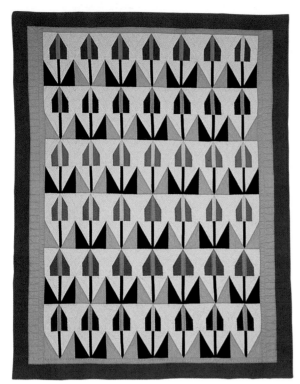

Pieced Tulip
Jean Musgrove; Sanford, Florida
Chad, *National Olympic Committee*

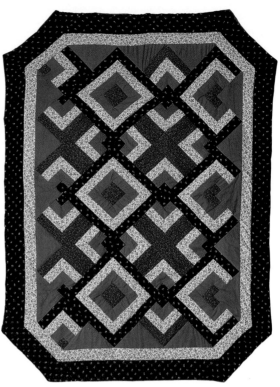

Friendship Knots
Jo Ann Miller; Marietta, Georgia
Chad, *Flagbearer*

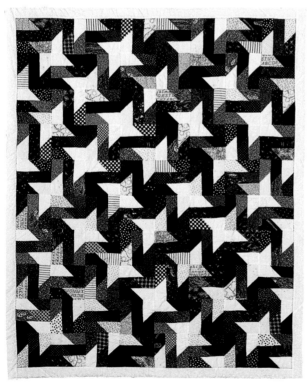

Harrison's Stars
Sharon Henderson; Lilburn, Georgia
Chile, *National Olympic Committee*

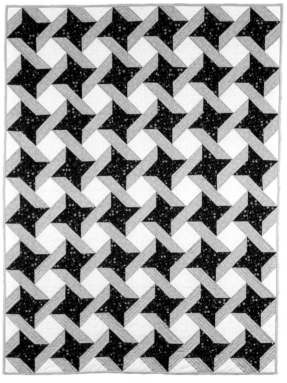

Friendship Star
Terry Saylor; Acworth, Georgia
Chile, *Flagbearer*

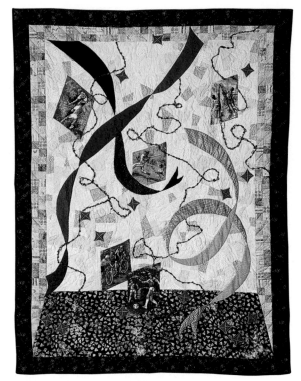

Celebration
Diane Knoblauch; Section, Alabama
People's Republic of China, *National Olympic Committee*

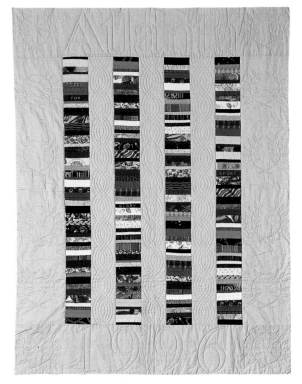

Chinese Coins
Kathleen Bates; Roswell, Georgia
People's Republic of China, *Flagbearer*

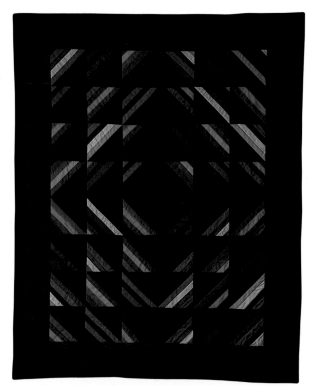

In the Amish Tradition
Susan Morrison; Stone Mountain, Georgia
Colombia, *National Olympic Committee*

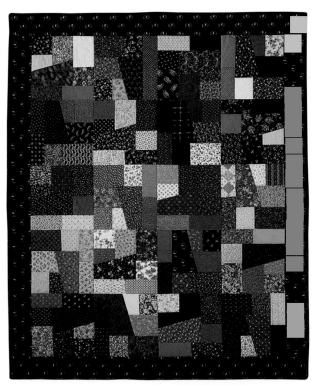

Crazy Patch
Glenda Fancher, Ella Redfern, Helen Smith, and
Carolyn Weed; Lilburn, Georgia
Colombia, *Flagbearer*

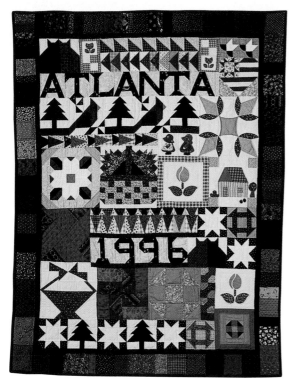

Atlanta 1996
Wednesday Quilters; Macon, Georgia
Comoros, *National Olympic Committee*

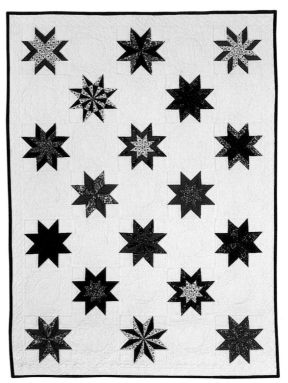

The Red, White, and Blue
Leslie Boss; Atlanta, Georgia
Comoros, *Flagbearer*

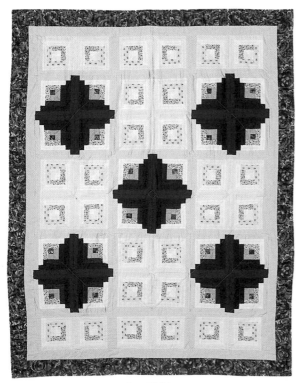

Log Cabin
Holley Schramski; Watkinsville, Georgia
Congo, *National Olympic Committee*

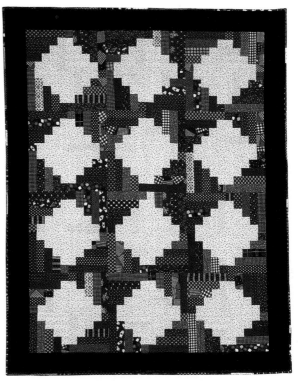

Patriotic Half Log Cabin
Sandra Flato; Peachtree City, Georgia
Congo, *Flagbearer*

Circles of Love, Peace & Unity
Ruth Rhoades; Martin, Georgia
Cook Islands, *National Olympic Committee*

Summer Stars
Sheila Galarneau Blair; Atlanta, Georgia
Cook Islands, *Flagbearer*

Roads to Georgia
Withlacoochee Quilters' Guild; Valdosta, Georgia
Costa Rica, *National Olympic Committee*

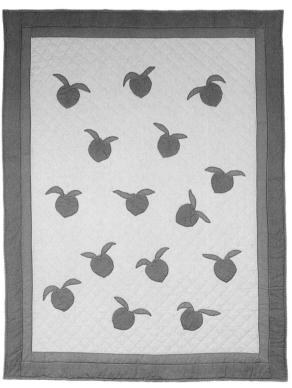

Georgia Peaches
Louise Smith; Dalton, Georgia
Costa Rica, *Flagbearer*

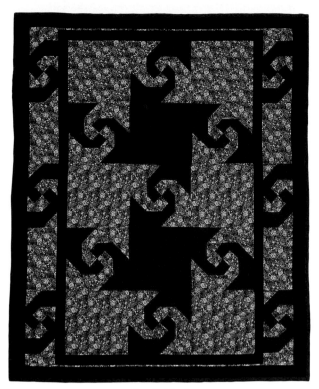

Snail's Trail
Frances Stribling and Alice Shriber;
Woodbury, Georgia
Côte d'Ivoire, *National Olympic Committee*

Friendship
Robin Jordan and Wendy Goddard; Temple, Georgia
Côte d'Ivoire, *Flagbearer*

Stepping Stones
Sharon Hultgren; Crosslake, Minnesota
Croatia, *National Olympic Committee*

Morning Glory
Jennie Dewberry; Newnan, Georgia
Croatia, *Flagbearer*

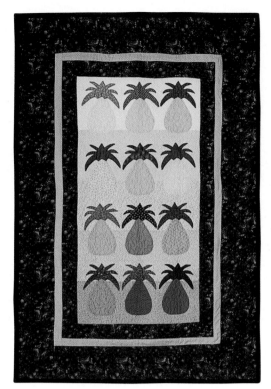

Pineapple
Dian Rice; Atlanta, Georgia
Cuba, *National Olympic Committee*

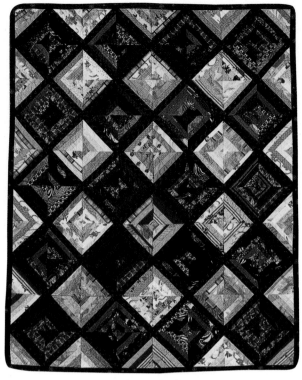

String Quilt
Frances Vass; Macon, Georgia
Cuba, *Flagbearer*

Georgia Pines
The Skipped Stitches–Heart of Georgia Quilt Guild;
Macon, Georgia
Cyprus, *National Olympic Committee*

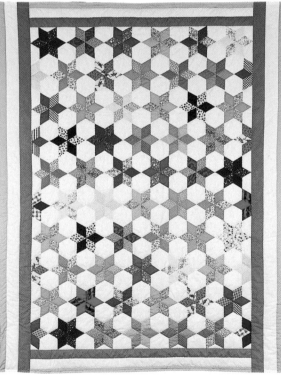

Calico Stars
Handcrafters Guild of Northwest Georgia;
Dalton, Georgia
Cyprus, *Flagbearer*

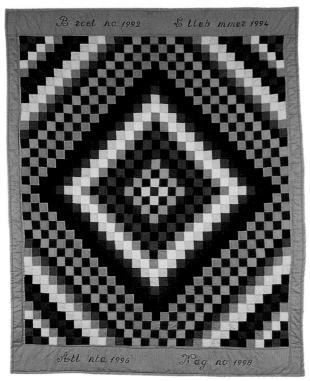

Trip Around the World in the 90s
Frances Enyart and friends; Zebulon, Georgia
Czech Republic, *National Olympic Committee*

Sampler
Katherine Thomas; Macon, Georgia
Czech Republic, *Flagbearer*

A Stroll Through the Streets of Georgia
Sandy Stites; Snellville, Georgia
Denmark, *National Olympic Committee*

Kaleidoscope
Richard Hood and Daryl Hood; Buford, Georgia
Denmark, *Flagbearer*

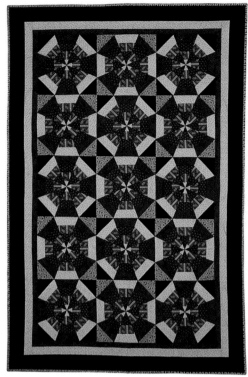

Kaleidoscope
Maureen McCarron; Lawrenceville, Georgia
Djibouti, *National Olympic Committee*

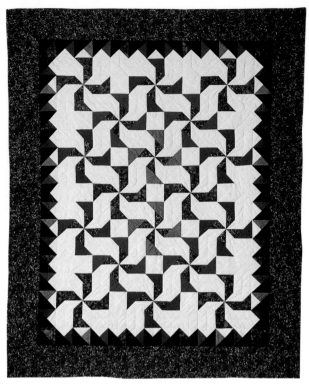

Streaks o' Gold
Leslie Boone; Lilburn, Georgia
Djibouti, *Flagbearer*

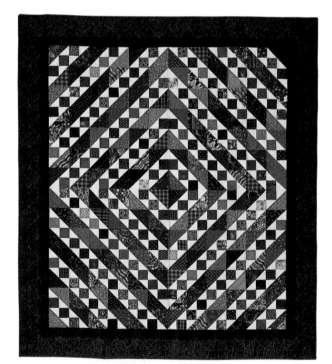

Paths to Friendship
Leslie Peck; Murrayville, Georgia
Dominica, *National Olympic Committee*

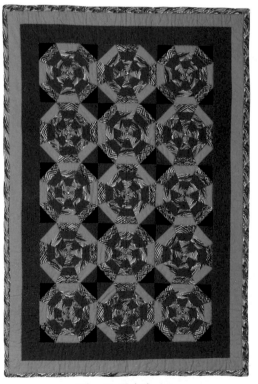

Olympic Kaleidoscope
Alberta Newbanks; Decatur, Georgia
Dominica, *Flagbearer*

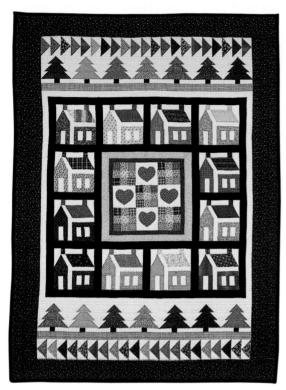

Our Togetherness
Shamrock Quilters; Dublin, Georgia
Dominican Republic, *National Olympic Committee*

Pines in the Panes
Linda Martin; Stone Mountain, Georgia
Dominican Republic, *Flagbearer*

Jewel Exchange
Lillian Thornton; Grayson, Georgia
Ecuador, *National Olympic Committee*

Olympic Spirit in the Universe
Lauren Rose; Norcross, Georgia
Ecuador, *Flagbearer*

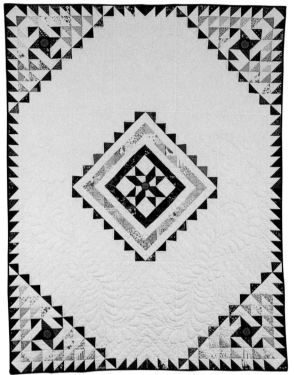

Fine Feathered Friend
Sammie Simpson; Alpharetta, Georgia
Egypt, *National Olympic Committee*

Lucky Leaves
Reagan Walker; Atlanta, Georgia
Egypt, *Flagbearer*

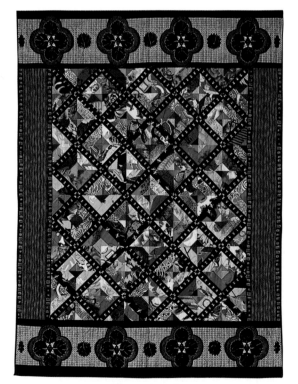

Fire in the Belly
Pat Stettler; Marietta, Georgia
El Salvador, *National Olympic Committee*

Stars & Stripes
Alpharetta Needleworkers–East Cobb Quilters' Guild;
Alpharetta, Georgia
El Salvador, *Flagbearer*

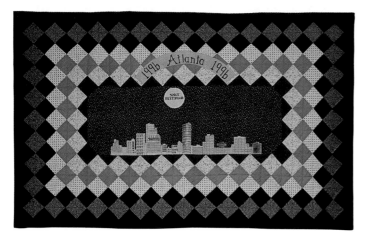

Welcome to Atlanta
Ruth Hitchcock; Las Vegas, Nevada
Equatorial Guinea, *National Olympic Committee*

Checkerboard
Winnie Dillingham; Mineral Bluff, Georgia
Equatorial Guinea, *Flagbearer*

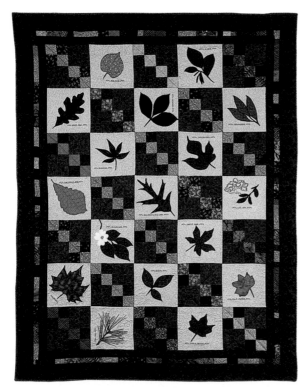

The Greens of Georgia
Peggie Marinos; Atlanta, Georgia
Estonia, *National Olympic Committee*

Hart Stitchers
The Hart Stitchers; Hartwell, Georgia
Estonia, *Flagbearer*

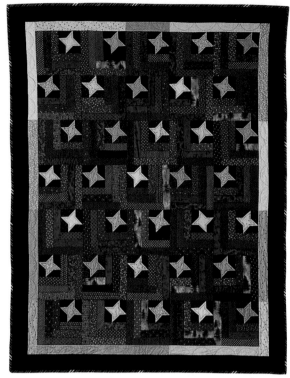

Friendship Stars for an Olympian
Sue Hardin; Carrollton, Georgia
Ethiopia, *National Olympic Committee*

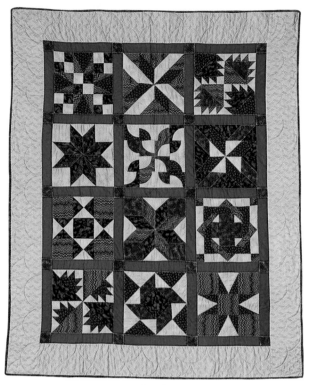

Sampler
Carole Thomas; Tucker, Georgia
Ethiopia, *Flagbearer*

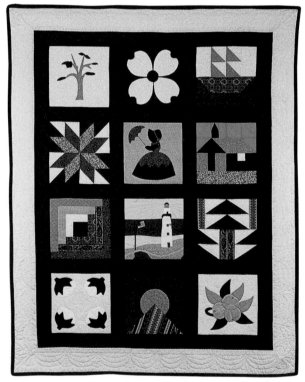

Georgia Potpourri
Lavender Mountain Quilt Guild; Rome, Georgia
Fiji, *National Olympic Committee*

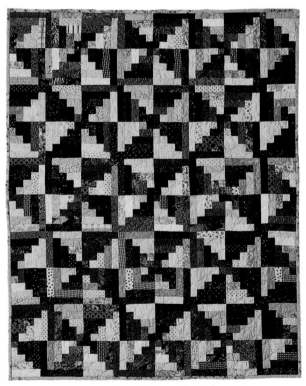

Georgia Log Cabin
Alice W. Crawford; Cumming, Georgia
Fiji, *Flagbearer*

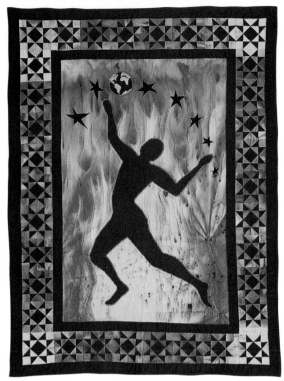

Olympic Stars
Ginger Haas; Marietta, Georgia
Finland, *National Olympic Committee*

Friendship
Shirley McKenzie; Conley, Georgia
Finland, *Flagbearer*

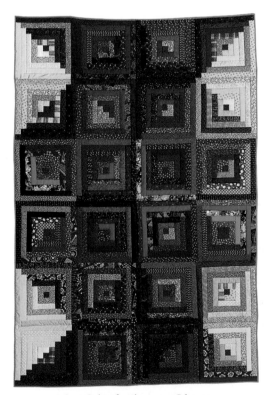

A Log Cabin for the 1996 Olympics
Betty Kaiser; Savannah, Georgia
Former Yugoslav Republic of Macedonia,
National Olympic Committee

Peace
Beth Koehler; Stone Mountain, Georgia
Former Yugoslav Republic of Macedonia, *Flagbearer*

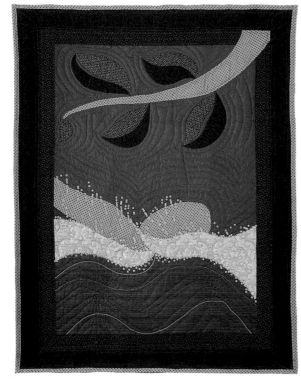

A Swimmer's Quest
Kathy Forbes; Alpharetta, Georgia
France, *National Olympic Committee*

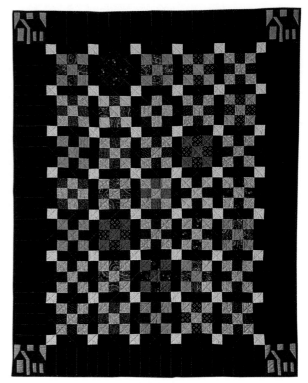

The Children's Nine-Patch
Northwoods Montessori School; Doraville, Georgia
France, *Flagbearer*

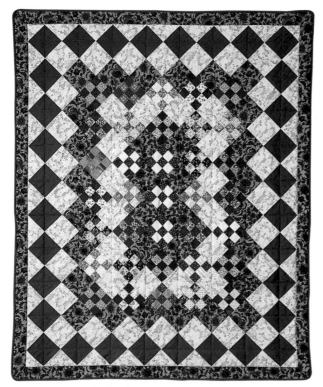

Go for the Gold in Emerald City
Corinne Echols; Lithonia, Georgia
Gabon, *National Olympic Committee*

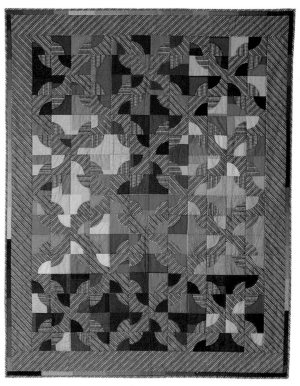

Path of Life
Jean Haas; Brevard, North Carolina
Gabon, *Flagbearer*

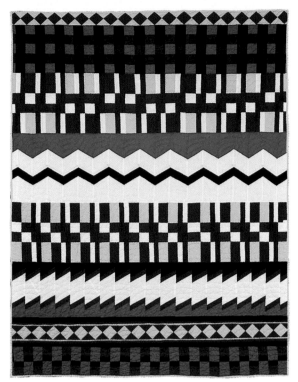

American Indian Welcome
Bobbi Cox; Lawrenceville, Georgia
Gambia, *National Olympic Committee*

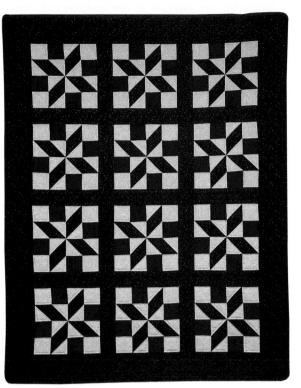

Clay's Choice
Anne B. Townes; Albany, Georgia
Gambia, *Flagbearer*

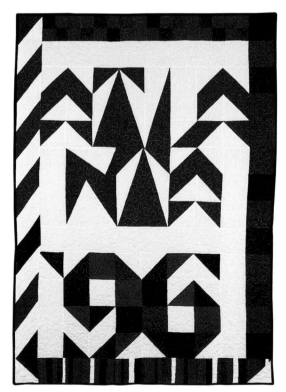

Atlanta '96
Maria Chisnall; Nassau, Bahamas
Georgia, *National Olympic Committee*

Double Irish Chain
Brenda Hines; Powder Springs, Georgia
Georgia, *Flagbearer*

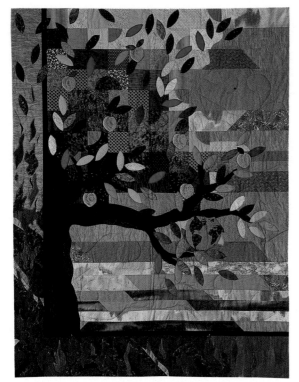

Atlanta's Peach Tree
Debra Steinmann; Atlanta, Georgia
Germany, *National Olympic Committee*

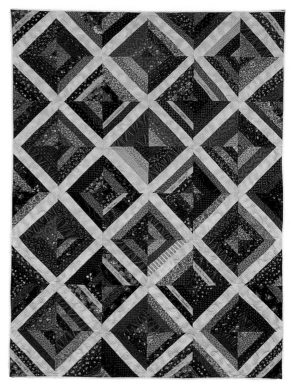

Girl Scout Friendship Quilt
Girl Scout Troop 1238; Lilburn, Georgia
Germany, *Flagbearer*

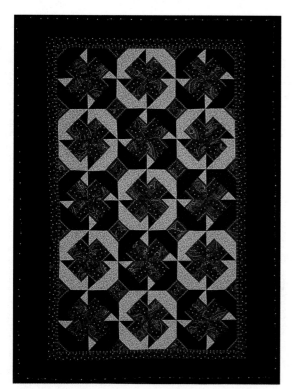

Mitre Box
Margaret LaBenne and Helen Gene Eberhart;
Tucker, Georgia
Ghana, *National Olympic Committee*

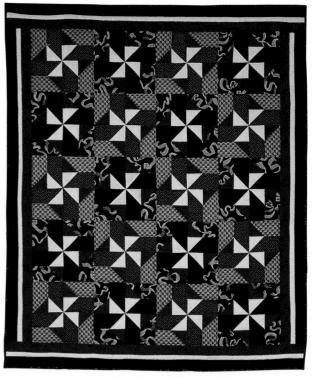

Petronella
Georgia Peach Quilters; Marietta, Georgia
Ghana, *Flagbearer*

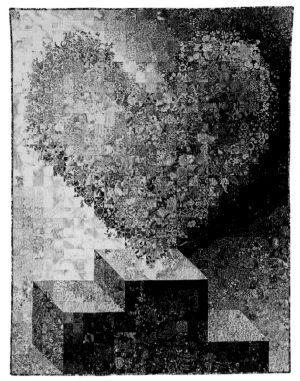

Go for the Gold—A Heart of Gold
Cindy Richards; Decatur, Georgia
Great Britain, *National Olympic Committee*

Save the Children
Cindy Fleischer; Roswell, Georgia
Great Britain, *Flagbearer*

Memories of Atlanta
Barbara Sanders; Watkinsville, Georgia
Greece, *National Olympic Committee*

Tricky Triangles
Crazy Quilters–Heart of Georgia Quilt Guild;
Macon, Georgia
Greece, *Flagbearer*

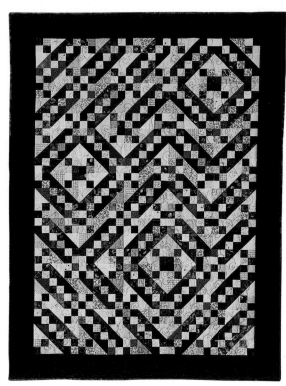

Jacob's Ladder
Margaret LaBenne; Tucker, Georgia
Grenada, *National Olympic Committee*

Stepping Stones to Friendship
Jeannine Hartman; Marietta, Georgia
Grenada, *Flagbearer*

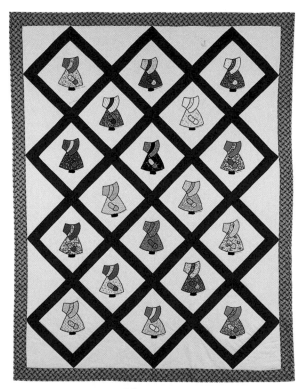

Olympic Sue
Ladies of Southern Heirlooms;
Powder Springs, Georgia
Guam, *National Olympic Committee*

Amish Pinwheel
Ola Coombs; Townville, South Carolina
Guam, *Flagbearer*

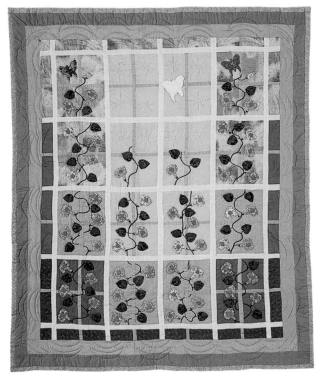

Windows of Life
Linda Tucker; Long Beach, California
Guatemala, *National Olympic Committee*

Color Me Georgia
Pat Schumacher; Lawrenceville, Georgia
Guatemala, *Flagbearer*

Friendship Flowers
Jane Grayson and Cathy Skrypek; Cumming, Georgia
Guinea, *National Olympic Committee*

Tumblers
Glenda Fancher and Helen Smith; Lilburn, Georgia
Guinea, *Flagbearer*

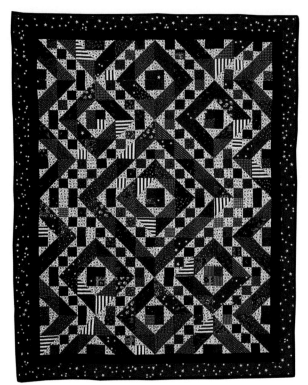

Welcome to Atlanta
Laverne Hart; Covington, Georgia
Guinea-Bissau, *National Olympic Committee*

Nine Patch Chain
Martha Mulinix; Kingston, Georgia
Guinea-Bissau, *Flagbearer*

Peach Star
Rumiko Nakajima; Macon, Georgia
Guyana, *National Olympic Committee*

Georgia on My Mind
Eleanor Wood; Gordon, Georgia
Guyana, *Flagbearer*

Georgia Kudzu Baskets
Karen Cummings; Marietta, Georgia
Haiti, *National Olympic Committee*

Milledgeville, Georgia Quilt
Civic Woman's Club of Milledgeville;
Milledgeville, Georgia
Haiti, *Flagbearer*

Firecracker
Virginia Hood; Marietta, Georgia
Honduras, *National Olympic Committee*

Olympic Bound
Susan Witek; Hayesville, North Carolina
Honduras, *Flagbearer*

Woodland Butterfly
Elaine Wood; Demorest, Georgia
Hong Kong, *National Olympic Committee*

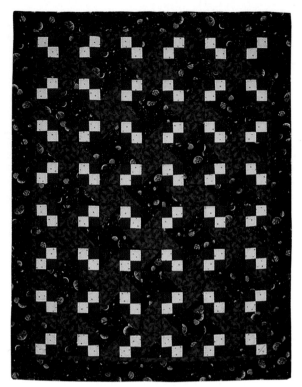

Stars of the Universe
Peggy Littrell and Helen Gene Eberhart;
Stone Mountain, Georgia
Hong Kong, *Flagbearer*

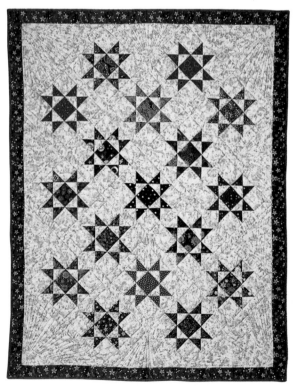

When You Wish Upon A Star
Ann Gravelle; Decatur, Georgia
Hungary, *National Olympic Committee*

World Friendship
Darnelle Eddings; Carrollton, Georgia
Hungary, *Flagbearer*

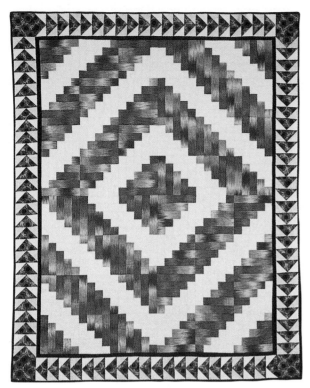

Passion for the Games
Sharon Jeffries; Fayetteville, Georgia
Iceland, *National Olympic Committee*

Star Gardens
Jan McGinty; Stone Mountain, Georgia
Iceland, *Flagbearer*

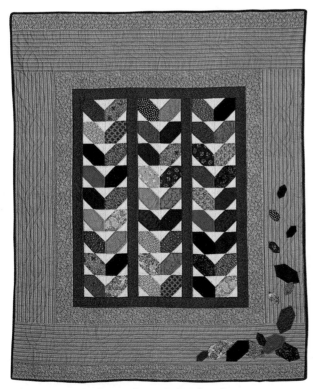

Georgia Leaves in Patchwork
Julia Anderson Bush; Ellenwood, Georgia
India, *National Olympic Committee*

Reach for the Stars
Diane Worley; Kennesaw, Georgia
India, *Flagbearer*

Georgia Autumn
Meredith L. Burdulis; Lawrenceville, Georgia
Indonesia, *National Olympic Committee*

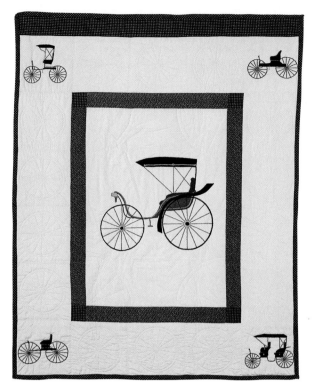

Barnesville Buggy Quilt
Johnstonville Quilters; Barnesville, Georgia
Indonesia, *Flagbearer*

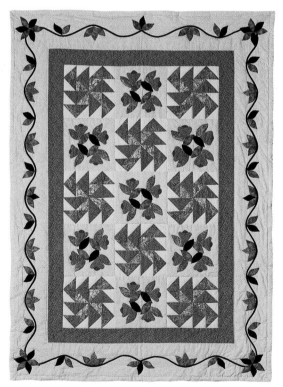

Pocketful of Posies
Cherokee Rose Quilters Guild; Douglasville, Georgia
Islamic Republic of Iran, *National Olympic Committee*

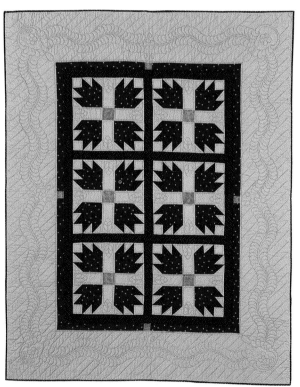

Starry Bears
Ann Taylor; Gainesville, Georgia
Islamic Republic of Iran, *Flagbearer*

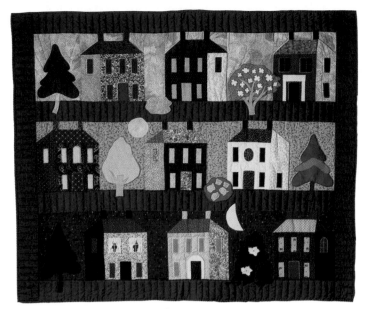

Atlanta Spring
Atlanta Intown Quilters; Atlanta, Georgia
Iraq, *National Olympic Committee*

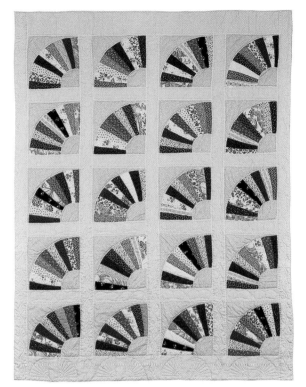

Grandmother's Fan
Mary Ann Carp; Riverdale, Georgia
Iraq, *Flagbearer*

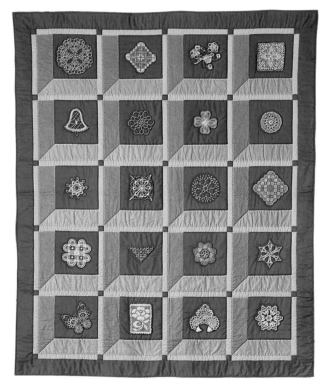

Threads of Lace in the Windows
International Old Lacers; Smyrna, Georgia
Ireland, *National Olympic Committee*

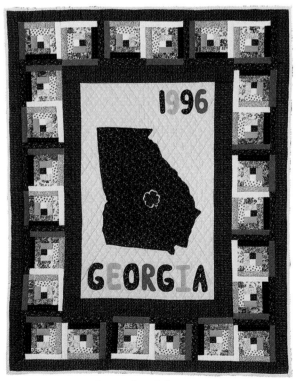

Georgia Log Cabin 1996
Laurens Happy Quilters; Dublin, Georgia
Ireland, *Flagbearer*

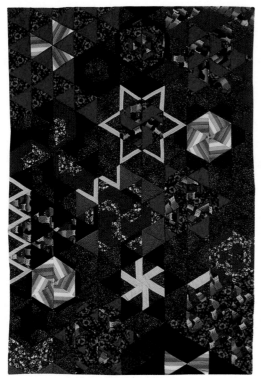

Kaleidoscope
Carrie Bibelhauser and Effie Hall; Norcross, Georgia
Israel, *National Olympic Committee*

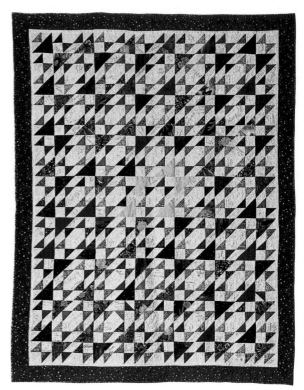

Dynamo Stars
Ellen Rosintoski; Doraville, Georgia
Israel, *Flagbearer*

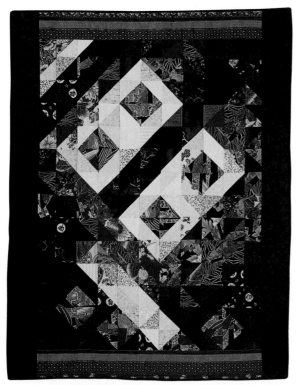

Centennial Olympics...And You Are There
Alice Mattimoe and Jan Brashears; Atlanta, Georgia
Italy, *National Olympic Committee*

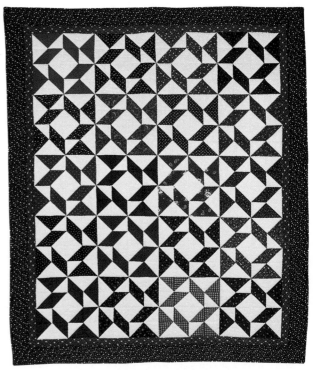

Windblown Squares
Betty Lewis; Lawrenceville, Georgia
Italy, *Flagbearer*

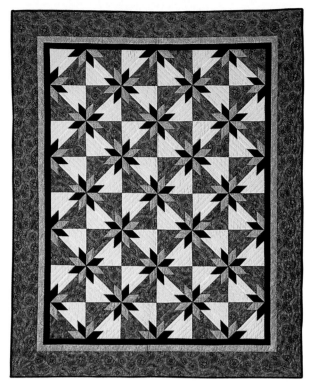

Aim for the Stars
Norma Hansen Balthazar; Chamblee, Georgia
Jamaica, *National Olympic Committee*

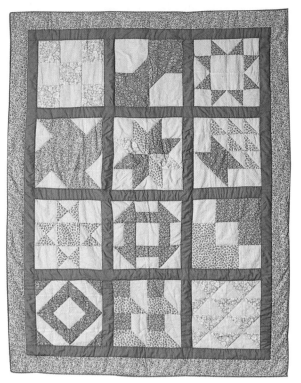

Pastel Sampler
Gwen Warner and Lauren Warner;
Lawrenceville, Georgia
Jamaica, *Flagbearer*

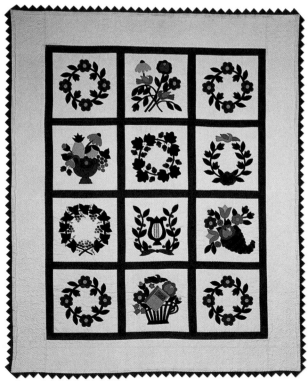

Friendship Album
Pat Fielding; Stone Mountain, Georgia
Japan, *National Olympic Committee*

Olympic Stars and Flags Around the World
Ann Ewald; Stone Mountain, Georgia
Japan, *Flagbearer*

Garden Twist
Phyllis Bradford; Winder, Georgia
Jordan, *National Olympic Committee*

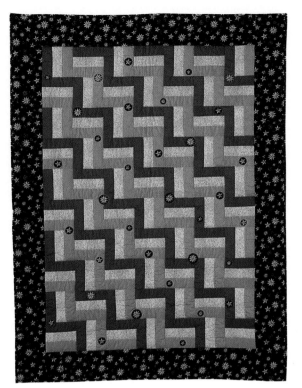

Stairsteps to the Stars
Sharon Hoff; Harrison, Tennessee
Jordan, *Flagbearer*

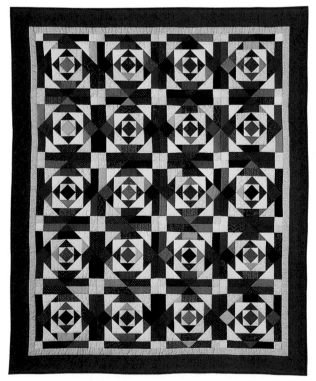

Corn Chowder
Marjorie Frost; East Point, Georgia
Kazakstan, *National Olympic Committee*

Bits & Pieces
Linda Hangen; Peachtree City, Georgia
Kazakstan, *Flagbearer*

Windblown Squares
Chamblee Star Quilt Guild; Chamblee, Georgia
Kenya, *National Olympic Committee*

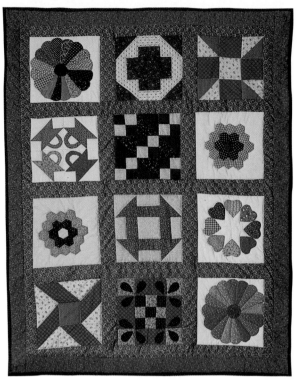

A Taste of Tradition
Ginny Werner; Marietta, Georgia
Kenya, *Flagbearer*

We Come...
Shirley Erickson; Athens, Georgia
Korea, *National Olympic Committee*

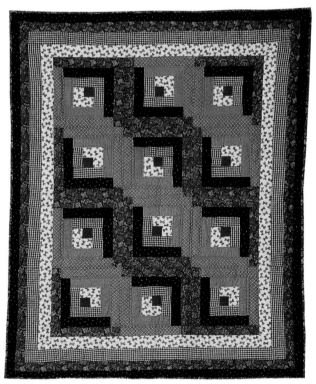

Log Cabin
Wednesday Quilters–Lapham-Patterson House;
Thomasville, Georgia
Korea, *Flagbearer*

Olympic Colors Quilt
Susan Kunze; Chamblee, Georgia
Kuwait, *National Olympic Committee*

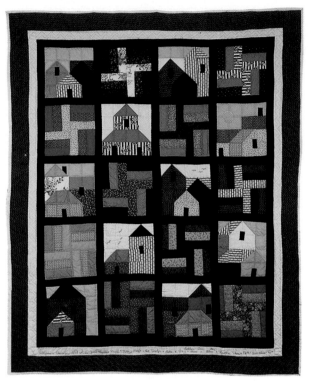

Houses and Gardens
Oak Grove Elementary School;
Peachtree City, Georgia
Kuwait, *Flagbearer*

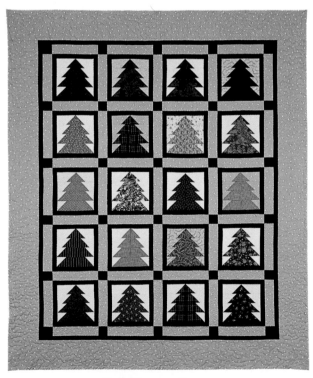

Quilt Pines over Georgia
Gwinnett Quilters Guild; Lilburn, Georgia
Kyrgyzstan, *National Olympic Committee*

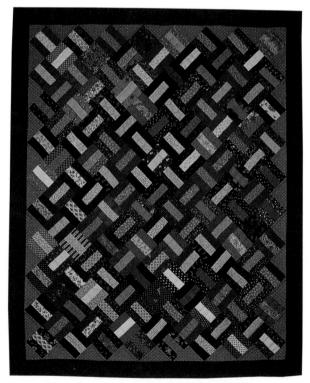

Georgia Scraps
Scrapaholics–Heart of Georgia Quilt Guild;
Macon, Georgia
Kyrgyzstan, *Flagbearer*

Cherokee Roses for You
Frances Hatcher; Stone Mountain, Georgia
Lao People's Democratic Republic,
National Olympic Committee

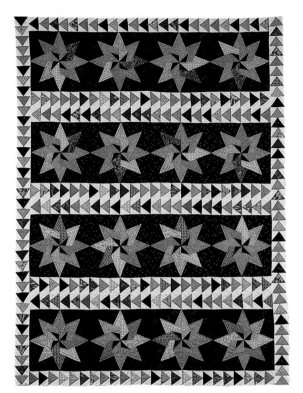

Peace on Earth
Mary Lou Mojonnier; Atlanta, Georgia
Lao People's Democratic Republic, *Flagbearer*

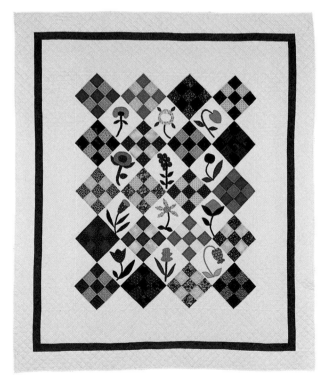

Country Garden
Sandra M. Coptsias; Plains, Georgia
Latvia, *National Olympic Committee*

From Georgia with Love
Jug Tavern Quilters; Winder, Georgia
Latvia, *Flagbearer*

Welcome Home
Cynthia G. Brundage; East Ridge, Tennessee
Lebanon, *National Olympic Committee*

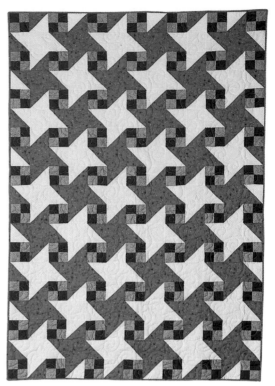

Universal Celebrations
Connie Dodson; Lithonia, Georgia
Lebanon, *Flagbearer*

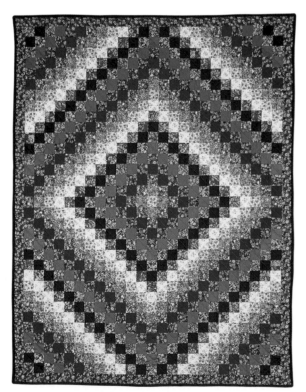

Trip Around the World
Anne Wearing; Lawrenceville, Georgia
Lesotho, *National Olympic Committee*

Friendship Star
Jane Peters Camp and Pamela Camp; Atlanta, Georgia
Lesotho, *Flagbearer*

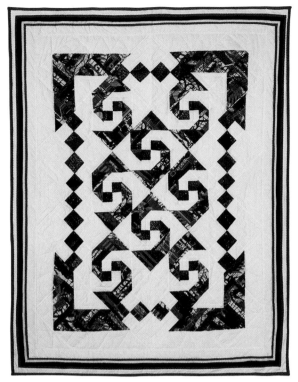

Simply...Congratulations
Huisha Kiongozi; Atlanta, Georgia
Liberia, *National Olympic Committee*

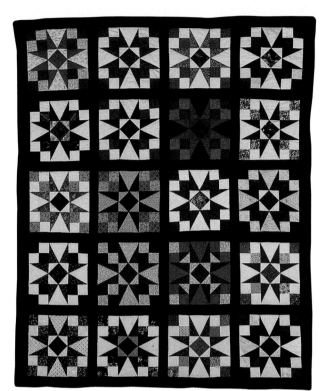

Learning Together
Nancy Jackman; Milledgeville, Georgia
Liberia, *Flagbearer*

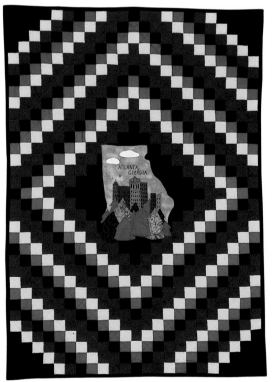

Trip Around the World
Sue Clark and Betty Windham; Conyers, Georgia
Libyan Arab Jamahiriya, *National Olympic Committee*

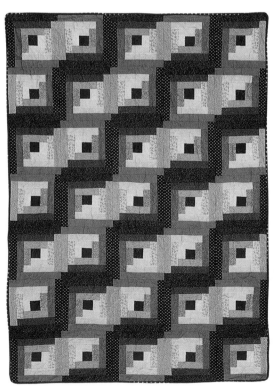

American Log Cabin
Ginny Wineinger; Stone Mountain, Georgia
Libyan Arab Jamahiriya, *Flagbearer*

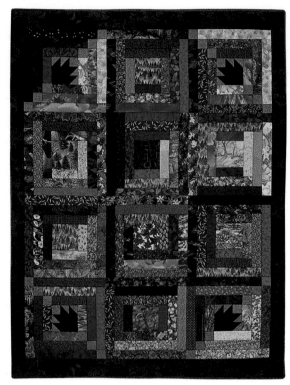

Appalachian Trail
Sandy Henry; Cumming, Georgia
Liechtenstein, *National Olympic Committee*

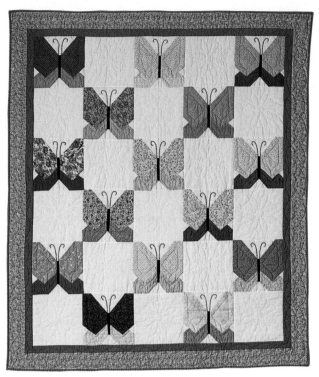

Metamorphosis
Seniors Enriched Living; Roswell, Georgia
Liechtenstein, *Flagbearer*

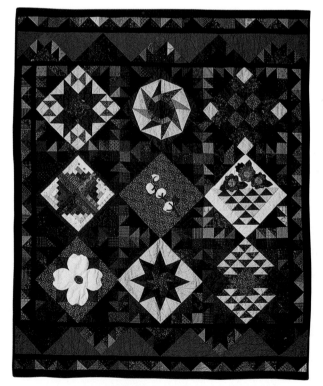

Sweet Georgia...Brown
Calico Quilter; Roswell, Georgia
Lithuania, *National Olympic Committee*

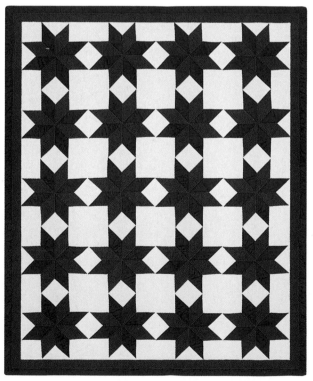

Welcome to Atlanta
Busy Bee Homemakers Club; Dalton, Georgia
Lithuania, *Flagbearer*

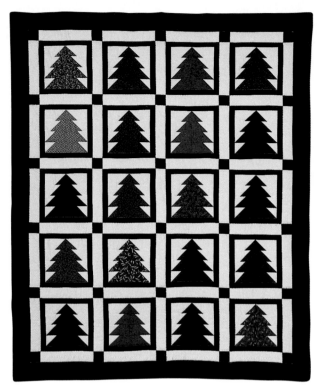

Georgia Pines
Shirley Durden; Loganville, Georgia
Luxembourg, *National Olympic Committee*

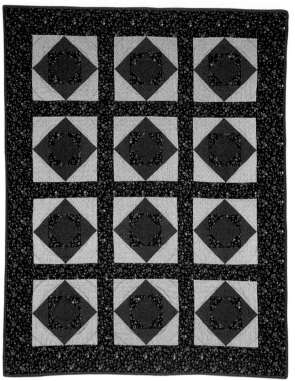

Circle of Friends
Joyce Jones; Macon, Georgia
Luxembourg, *Flagbearer*

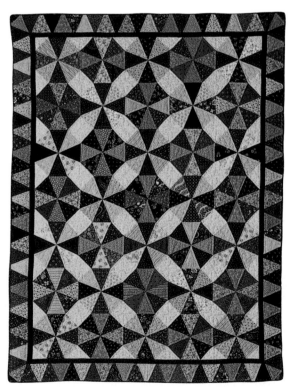

Kaleidoscope
Irene McLaren; Hiawassee, Georgia
Madagascar, *National Olympic Committee*

Shoo Fly
Undercover Quilters; Jonesboro, Georgia
Madagascar, *Flagbearer*

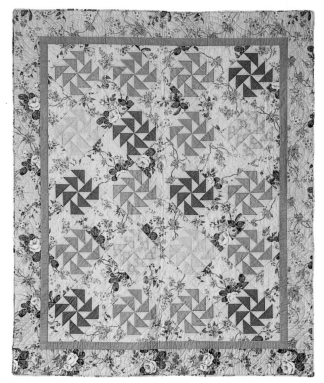

Olympic Memories
Joyce Selin; Stone Mountain, Georgia
Malawi, *National Olympic Committee*

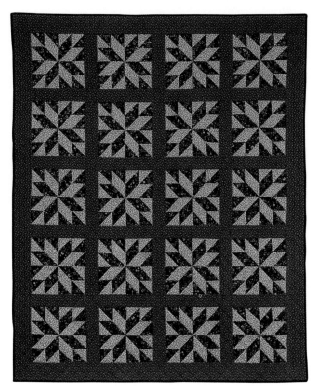

Annie's Choice
Chamblee Star Quilt Guild; Chamblee, Georgia
Malawi, *Flagbearer*

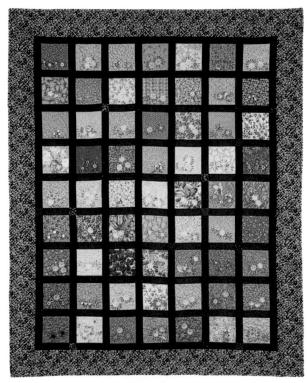

Flower Boxes
Ellen Jennings; Marietta, Georgia
Malaysia, *National Olympic Committee*

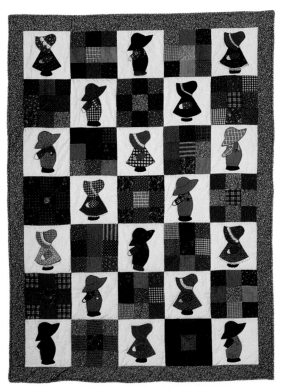

Sunbonnet Sue and Overall Sam Go Abroad
Jan Brumbelow, Beverly Gray, Kathy Heidish,
Diana Kelly, and Ellen White; Lawrenceville, Georgia
Malaysia, *Flagbearer*

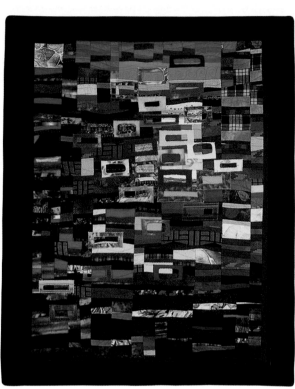

Windows Over Georgia
Elizabeth Barton; Athens, Georgia
Maldives, *National Olympic Committee*

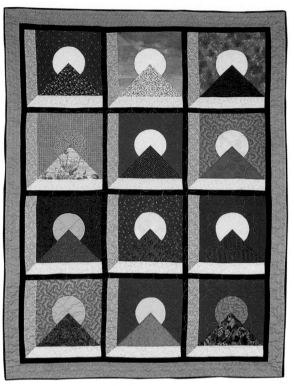

Coal Mountain
Piecemakers Quilt Guild; Cumming, Georgia
Maldives, *Flagbearer*

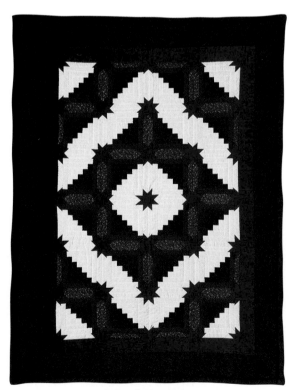

Colorado Log Cabin
Anne DeWeese; Lawrenceville, Georgia
Mali, *National Olympic Committee*

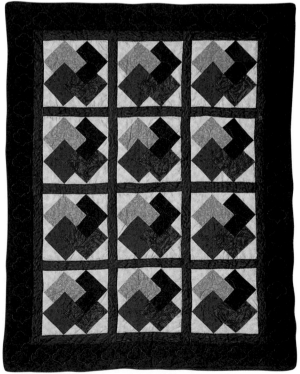

Card Tricks
Troop 1090, Northwest Georgia Girl Scout Council;
Duluth, Georgia
Mali, *Flagbearer*

Trip Around the World Olympics
Lora Pasco; Atlanta, Georgia
Malta, *National Olympic Committee*

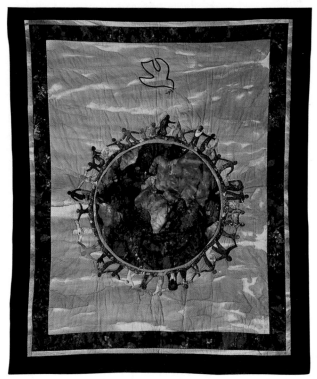

Peace, the Hope of the World
Dorothy Kenney; Stone Mountain, Georgia
Malta, *Flagbearer*

African Stars
Gwen Warner; Lawrenceville, Georgia
Mauritania, *National Olympic Committee*

Variable Star
Cecil Wrenn; Albany, Georgia
Mauritania, *Flagbearer*

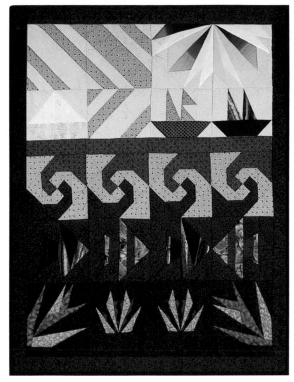

Fathom the Possibilities
Mary Anne Bradford; Athens, Georgia
Mauritius, *National Olympic Committee*

Double Nine-Patch Variation
Anne Barrett; Oxford, Alabama
Mauritius, *Flagbearer*

Sunburst Quilt
Linda Camp; Ellerslie, Georgia
Mexico, *National Olympic Committee*

Olympic Friendship
Monique Foley; Peachtree City, Georgia
Mexico, *Flagbearer*

Quilt of Stars
Elizabeth Cressler; Roswell, Georgia
Republic of Moldova, *National Olympic Committee*

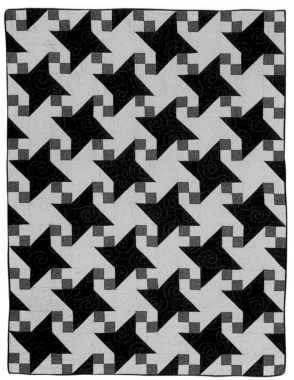

Milky Way
Ginny Wineinger; Stone Mountain, Georgia
Republic of Moldova, *Flagbearer*

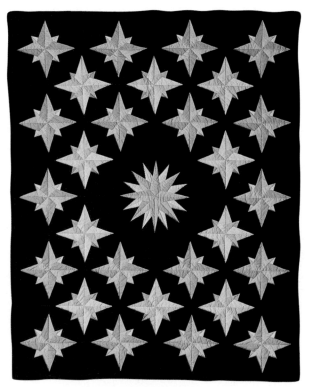

Stars Over Georgia
Vicki Hutton; Marietta, Georgia
Monaco, *National Olympic Committee*

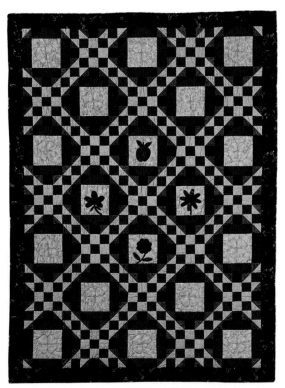

Atlanta 1996
Cleo Ward and Beth Brady; Decatur, Georgia
Monaco, *Flagbearer*

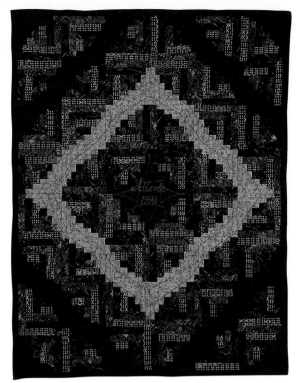

Atlanta 1996
Patsy Eckman; Cumming, Georgia
Mongolia, *National Olympic Committee*

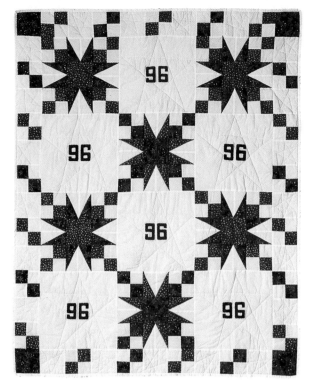

Stars of '96
Juanita Windham; Douglasville, Georgia
Mongolia, *Flagbearer*

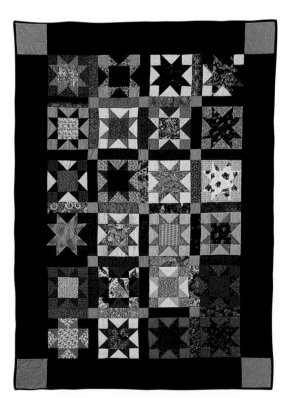

Stars Over Georgia
Withlacoochee Quilters' Guild; Valdosta, Georgia
Morocco, *National Olympic Committee*

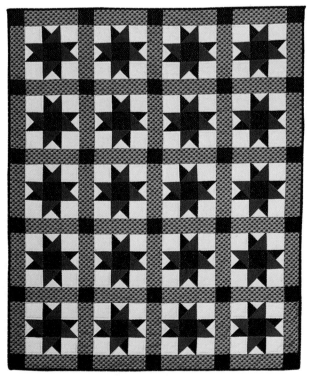

Stars & Stripes
Beth Beers; Smyrna, Georgia
Morocco, *Flagbearer*

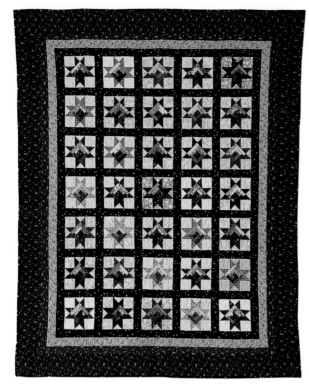

Log Cabin Stars
Jackie Johnson and Jill Schneider; Cumming, Georgia
Mozambique, *National Olympic Committee*

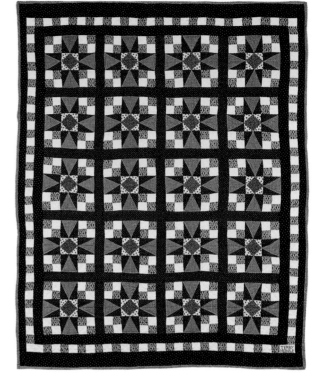

Shoot for the Stars
Terry Huddle; Warner Robins, Georgia
Mozambique, *Flagbearer*

Amazing Georgia
Linda Walgate Bitley; Smyrna, Georgia
Myanmar, *National Olympic Committee*

Ladder to the Gold
Sally Poupard; Macon, Georgia
Myanmar, *Flagbearer*

Doorways to Understanding
Shirley Rathkopf; Cumming, Georgia
Namibia, *National Olympic Committee*

Georgia Dogwoods
Lynn Harned; Lawrenceville, Georgia
Namibia, *Flagbearer*

Friendship Baskets
Deborah McLaughlin; Marietta, Georgia
Nauru, *National Olympic Committee*

Windmills: United Yet Unique
High Meadows School; Roswell, Georgia
Nauru, *Flagbearer*

Pineapple Log Cabin
Pamela Reis; Alpharetta, Georgia
Nepal, *National Olympic Committee*

Olympic Chain
Laurie Wragg; Lawrenceville, Georgia
Nepal, *Flagbearer*

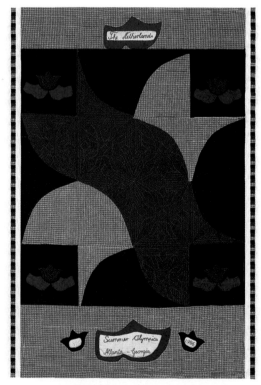

Friendship and Cooperation
Ursula Teeuw; Marietta, Georgia
Netherlands, *National Olympic Committee*

North-South Double Flight
Jewel Edwards; Statesboro, Georgia
Netherlands, *Flagbearer*

Georgia on My Mind
Shirley McKinney; Swainsboro, Georgia
Netherlands Antilles, *National Olympic Committee*

Double Wedding Ring
Sue Rupf; Kennesaw, Georgia
Netherlands Antilles, *Flagbearer*

Friendship Quilt
Yoko Washimi; Dublin, Georgia
New Zealand, *National Olympic Committee*

Stars of the Olympic Spirit
Vicki Tillery; Lilburn, Georgia
New Zealand, *Flagbearer*

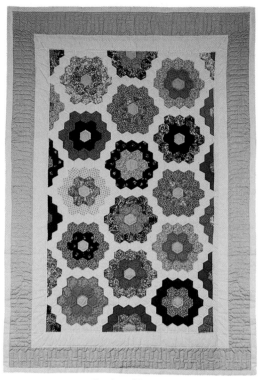

Spirit of Atlanta
Mummy Group–Yellow Daisy Quilters;
Decatur, Georgia
Nicaragua, *National Olympic Committee*

Garden of Dreams
Tommie Freeman; Carrollton, Georgia
Nicaragua, *Flagbearer*

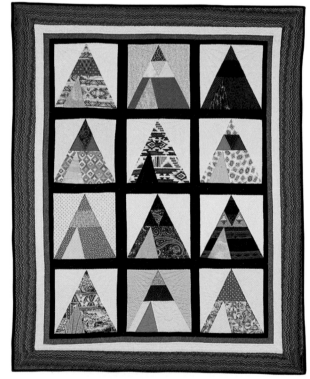

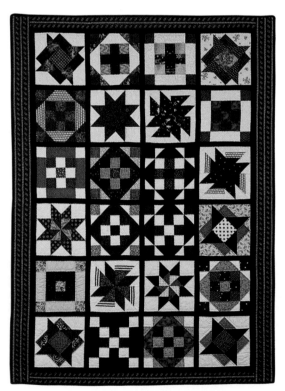

American Indian Teepee
Jill Schneider; Cumming, Georgia
Niger, *National Olympic Committee*

Hurrah for the Red, White, and Blue
The Quilting Gourmets–Heart of Georgia Quilt Guild;
Macon, Georgia
Niger, *Flagbearer*

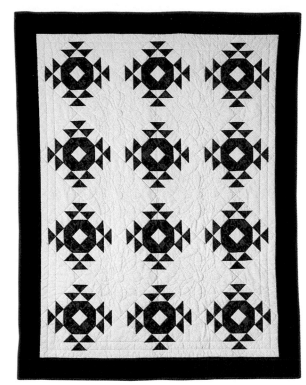

Wedding Ring
Radine Robinson; Decatur, Georgia
Nigeria, *National Olympic Committee*

Nine Patch
Laura DeMarco; Blairsville, Georgia
Nigeria, *Flagbearer*

Winter Memories
Morning Stitch-in Group–Yellow Daisy Quilters;
Decatur, Georgia
Norway, *National Olympic Committee*

Stars Over Atlanta
Jessie Quick; Douglasville, Georgia
Norway, *Flagbearer*

Welcome to My Country, Welcome to My Cabin
Jane Glaze; Doraville, Georgia
Oman, *National Olympic Committee*

Georgia on My Mind
Carolyn Jeffares; Atlanta, Georgia
Oman, *Flagbearer*

Bound Four the Games
Ruth E. Pomroy; Macon, Georgia
Pakistan, *National Olympic Committee*

Southern Pines
Donna Sue Allen; Fayetteville, North Carolina
Pakistan, *Flagbearer*

Delectable Olympic Mountains
Joan Lucas; Burnham, Bucks, England
Palestine, *National Olympic Committee*

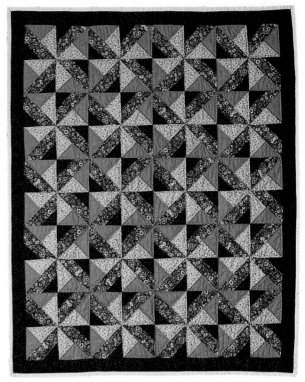

Pinwheel Quilt
Mary Parrot Black, Fairy Fowler, Evelyn McCord,
and Mary Wilson; Yatesville, Georgia
Palestine, *Flagbearer*

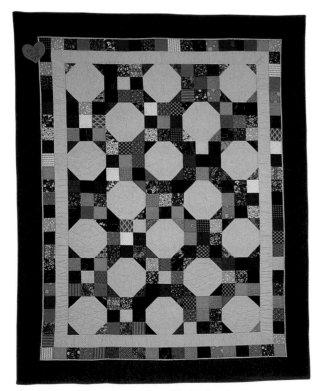

Let Us Piece Our World Together
Sandy Myers; Gainesville, Georgia
Panama, *National Olympic Committee*

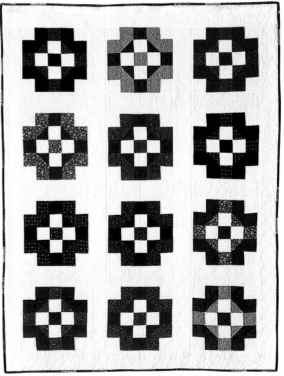

Calico Dreams
Jackie Parish; Martinez, Georgia
Panama, *Flagbearer*

From the Mountains to the Sea
Laurens Happy Quilters; Dublin, Georgia
Papua New Guinea, *National Olympic Committee*

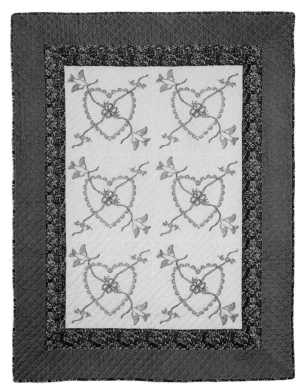

Dove of Peace
Annette Desautels, Emma Bodine, and Fannie Fowler;
Acworth, Georgia
Papua New Guinea, *Flagbearer*

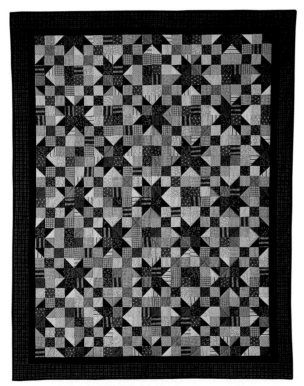

Olympic Stars
Sally Babcock; Murrayville, Georgia
Paraguay, *National Olympic Committee*

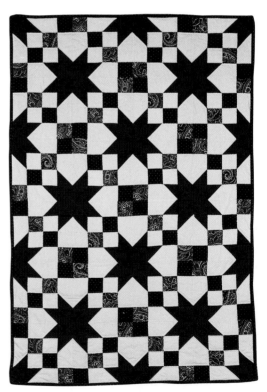

Stars in Georgia
Hilda Pruett; Macon, Georgia
Paraguay, *Flagbearer*

Garden Paths at Midnight
Fay Lovein; Macon, Georgia
Democratic People's Republic of Korea,
National Olympic Committee

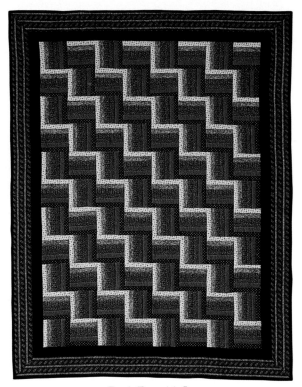

Don't Fence Me In
Fran Dadisman; Gainesville, Georgia
Democratic People's Republic of Korea, *Flagbearer*

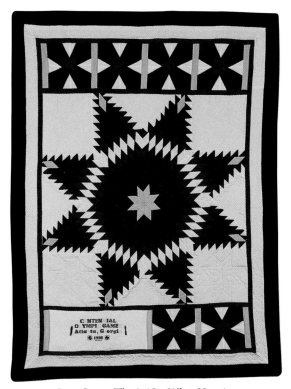

Lone Star—That's Not What You Are
Sally Schuyler; Atlanta, Georgia
Peru, *National Olympic Committee*

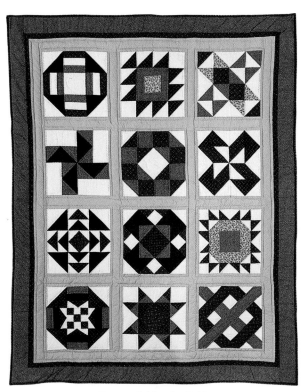

Surrounded by the Gold
Cynthia Zimmerman; Concord, Georgia
Peru, *Flagbearer*

Tick Tock
Deirdre C. Greer; Columbus, Georgia
Philippines, *National Olympic Committee*

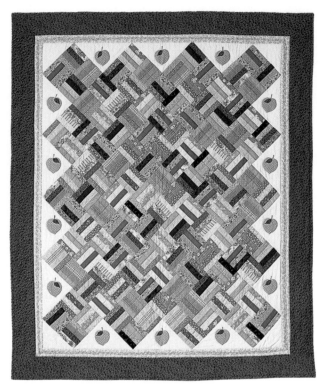

Georgia Farmlands
Jeanne Adams and Ardis Young; Covington, Georgia
Philippines, *Flagbearer*

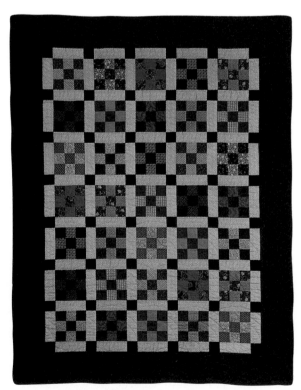

Citius, Altius, Fortius: Swifter, Higher, Stronger
Anita Zaleski Weinraub; Norcross, Georgia
Poland, *National Olympic Committee*

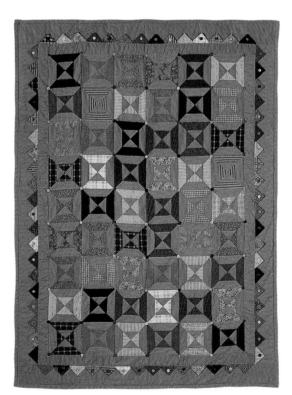

The Button Quilt
Kathleen Peacock; Jonesboro, Georgia
Poland, *Flagbearer*

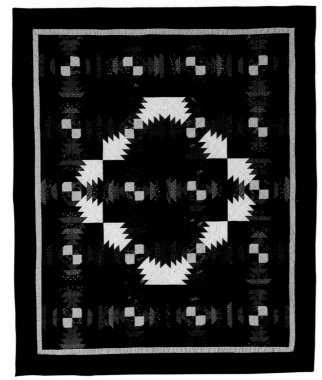

Welcome...In Any Language
Holly Anderson; Cumming, Georgia
Portugal, *National Olympic Committee*

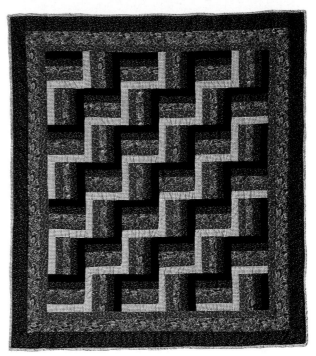

Olympic Rail Fence
Marilyn Clark; Carrollton, Georgia
Portugal, *Flagbearer*

Georgia on My Mind
Calico Quilter; Roswell, Georgia
Puerto Rico, *National Olympic Committee*

Olympic Roads
Nancy E. Sohl; Cumming, Georgia
Puerto Rico, *Flagbearer*

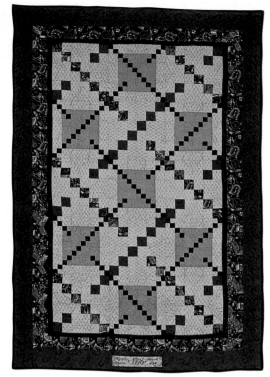

Georgia Crossroads
Edie Wilbur; Ellenwood, Georgia
Qatar, *National Olympic Committee*

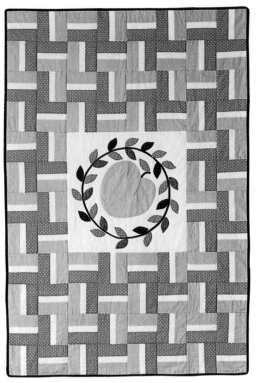

Georgia Peach Friendship Quilt
Bag Ladies Quilt Group; Norcross, Georgia
Qatar, *Flagbearer*

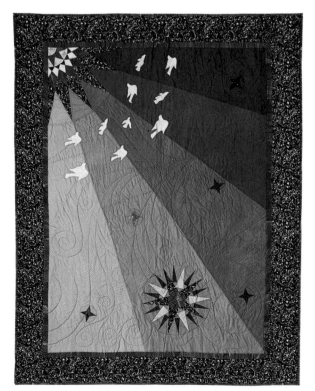

Wind Beneath My Wings
Lori Edwards; Stone Mountain, Georgia
Romania, *National Olympic Committee*

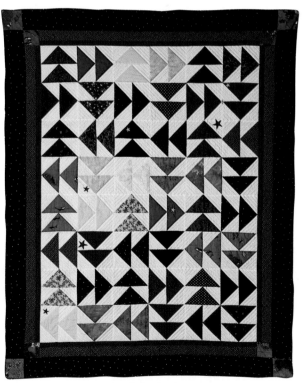

Reach for the Stars
Meg Fisher; Marietta, Georgia
Romania, *Flagbearer*

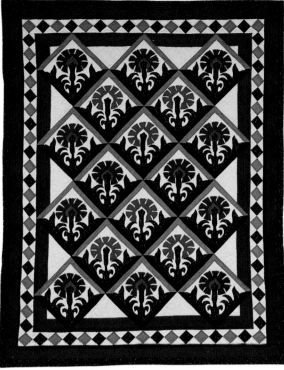

Claret Cup Cactus
Gladness Slingluff; Guys Mills, Pennsylvania
Russian Federation, *National Olympic Committee*

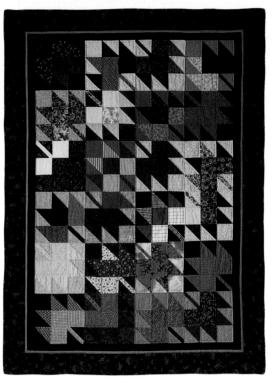

Leaves of Friendship
Places to Bee—East Cobb Quilters' Guild;
Woodstock, Georgia
Russian Federation, *Flagbearer*

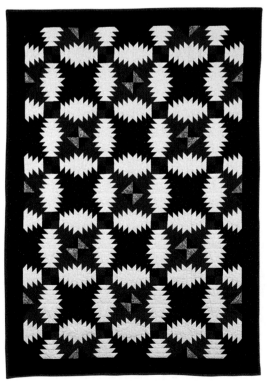

Pineapple of Fairburn
Old Campbell County Quilters; Fairburn, Georgia
Rwanda, *National Olympic Committee*

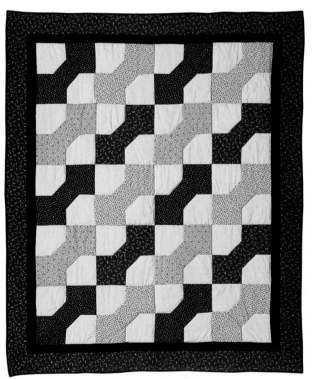

Americana Bow Tie
Comforting Quilters; Lawrenceville, Georgia
Rwanda, *Flagbearer*

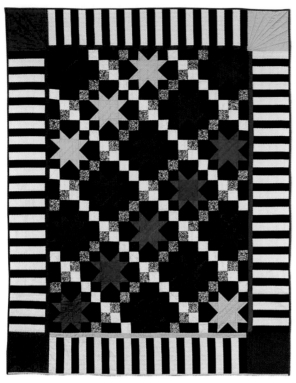

Olympic Stars
Arlene Teare; Marietta, Georgia
Saint Kitts and Nevis, *National Olympic Committee*

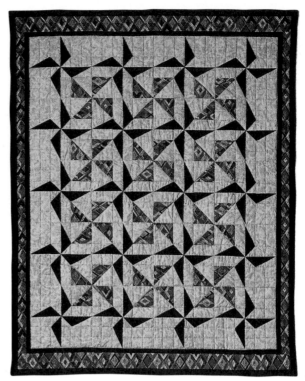

Birds of Paradise
Lucy Sessions; Macon, Georgia
Saint Kitts and Nevis, *Flagbearer*

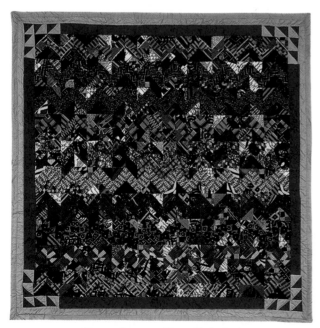

African-American Kente Cloth Quilt
Ruby Jackson; Fairburn, Georgia
Saint Lucia, *National Olympic Committee*

Half Log Cabin
Margaret LaBenne; Tucker, Georgia
Saint Lucia, *Flagbearer*

Rainbow of Stars
Iris Quilters; Griffin, Georgia
Saint Vincent and The Grenadines,
National Olympic Committee

Ocean Waves
Brunswick Homemakers Club; Brunswick, Georgia
St. Vincent and The Grenadines, *Flagbearer*

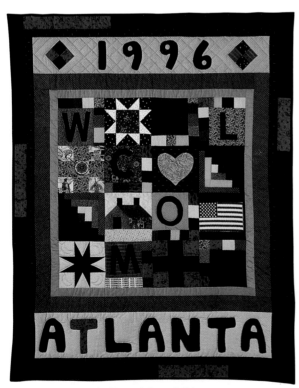

A Warm Atlanta Welcome
Sue Davis; Alpharetta, Georgia
San Marino, *National Olympic Committee*

Deborah's Southern Star
Deborah Glover; Alpharetta, Georgia
San Marino, *Flagbearer*

Jewels of the Chattahoochee
Elaine Mote; Duluth, Georgia
Saõ Tome and Princípe, *National Olympic Committee*

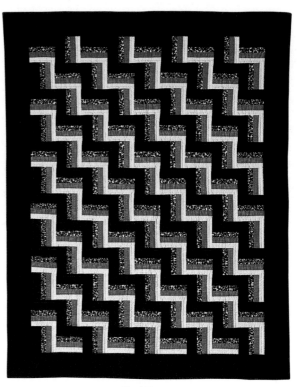

Rail Fence
Sue Shippey; Tifton, Georgia
Saõ Tome and Princípe, *Flagbearer*

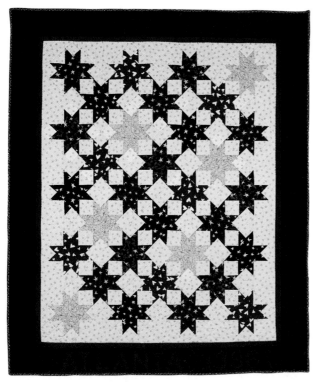

Olympic Stars
Sylvia Johnson; Marietta, Georgia
Saudi Arabia, *National Olympic Committee*

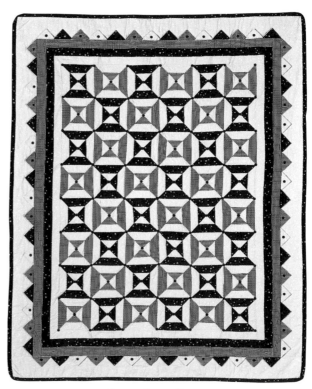

Stars & Bars & Buttons
Mamie Lawlor; Lawrenceville, Georgia
Saudi Arabia, *Flagbearer*

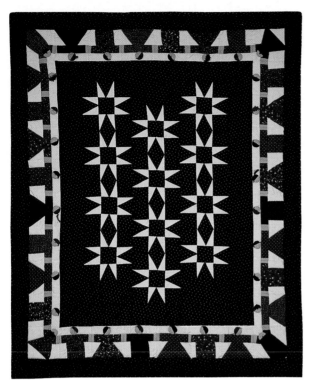

Reaching for the Stars
Marty Ruppert; Stone Mountain, Georgia
Senegal, *National Olympic Committee*

Summer Nights in Georgia
Nancy Rogers; Roswell, Georgia
Senegal, *Flagbearer*

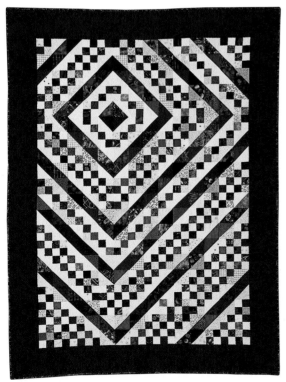

Pathway to the Olympics
Shannon Armstrong; Stone Mountain, Georgia
Seychelles, *National Olympic Committee*

Memories of Georgia
Carole Thorpe; Chesapeake, Virginia
Seychelles, *Flagbearer*

Log Cabin Schoolhouse
Ruth McKinley; Jonesboro, Georgia
Sierra Leone, *National Olympic Committee*

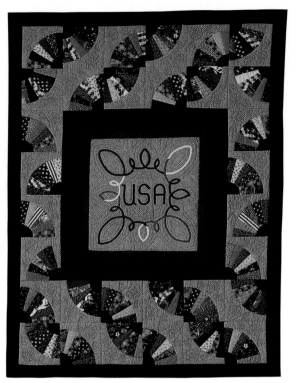

Georgia Friendship Fan
Georgia Friendship Quilters Guild;
Lithia Springs, Georgia
Sierra Leone, *Flagbearer*

Town & Country USA
Carol Matthews; Marietta, Georgia
Singapore, *National Olympic Committee*

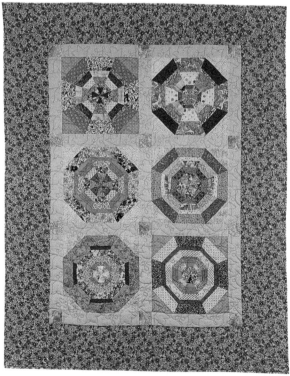

Spider Web Olympic
Day and Night Quilters; Fayetteville, Georgia
Singapore, *Flagbearer*

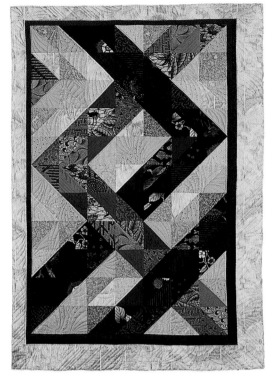

Traversing Paths
Barbara Thurman Butler; Marietta, Georgia
Slovakia, *National Olympic Committee*

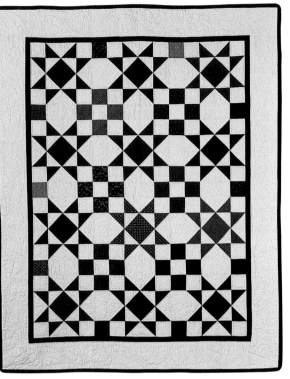

A Good Cotton Quilt
Valerie Yingling; Alpharetta, Georgia
Slovakia, *Flagbearer*

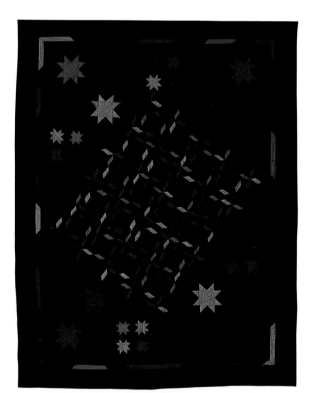

Olympic Fireworks
Karin Snyder; Marietta, Georgia
Slovenia, *National Olympic Committee*

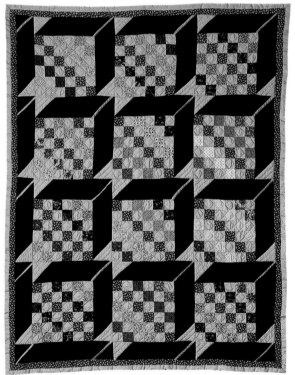

Test Pattern
Louise Carswell; Toccoa, Georgia
Slovenia, *Flagbearer*

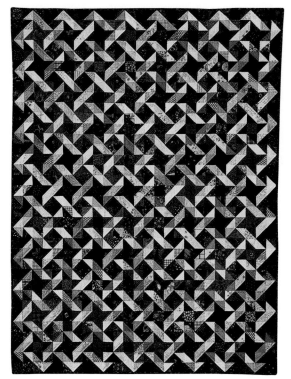

Friendship Star
Helen Swerske; Lawrenceville, Georgia
Solomon Islands, *National Olympic Committee*

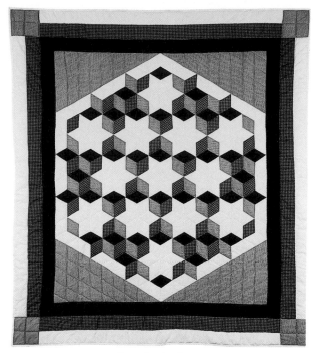

Shoot for the Stars
Monday Night Craft Group; Lovejoy, Georgia
Solomon Islands, *Flagbearer*

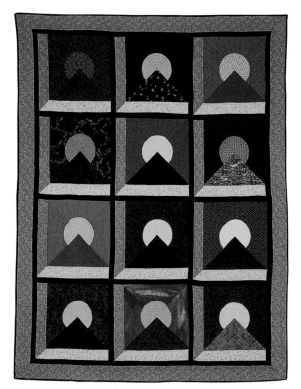

Sawnee Mountain
Piecemakers Quilt Guild; Cumming, Georgia
Somalia, *National Olympic Committee*

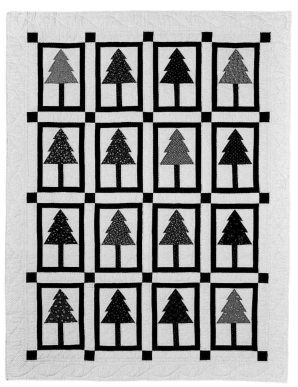

Georgia Pines
Jeannette Hart; Eatonton, Georgia
Somalia, *Flagbearer*

Southern Hospitality
Alice M. Berg; Marietta, Georgia
South Africa, *National Olympic Committee*

Southern Comforts
Sheila Cartwright; Lithia Springs, Georgia
South Africa, *Flagbearer*

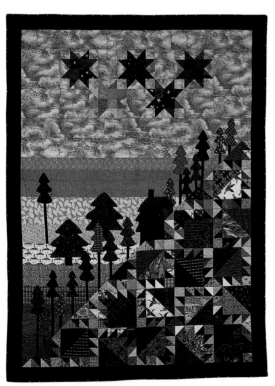

Georgia Mountains and Pines
Mary Ellen Von Holt; Marietta, Georgia
Spain, *National Olympic Committee*

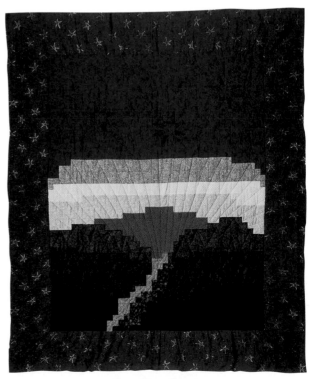

Stars Over Georgia
Debora Clem; Chattanooga, Tennessee
Spain, *Flagbearer*

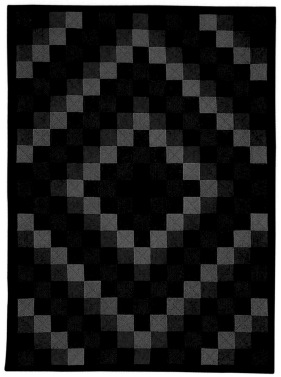

Trip Around the World
Pamela Winberg; Dawsonville, Georgia
Sri Lanka, *National Olympic Committee*

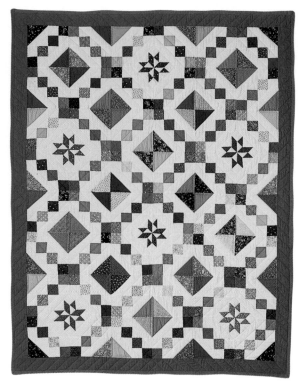

Pathway to the Stars
Betty Kitchens; Macon, Georgia
Sri Lanka, *Flagbearer*

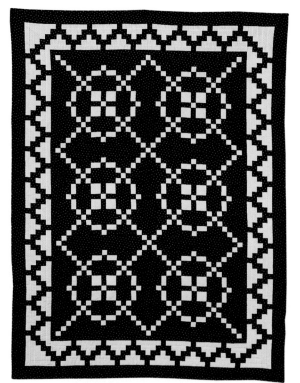

Building Blocks Instead of Walls
Fern Richardson; Chamblee, Georgia
Sudan, *National Olympic Committee*

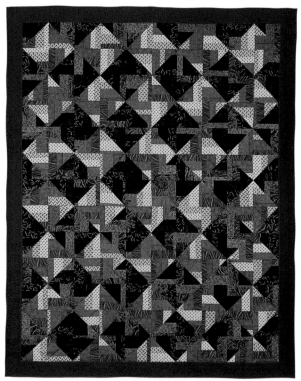

Strips That Sizzle
Patsy Eckman and Sandy Henry; Cumming, Georgia
Sudan, *Flagbearer*

Savannah Sails
Calico Stitchers; Savannah, Georgia
Suriname, *National Olympic Committee*

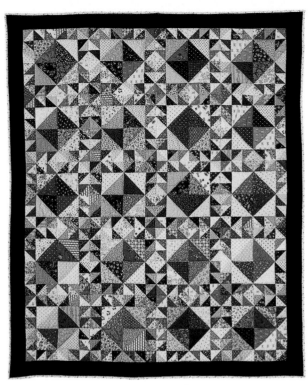

Scrappy Bear Claw
Carol Tucker; Conyers, Georgia
Suriname, *Flagbearer*

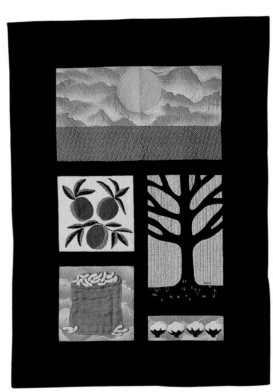

Georgia's Bounty
Madeline Hawley; Athens, Georgia
Swaziland, *National Olympic Committee*

Nine Patch
Nine Patchers–Heart of Georgia Quilt Guild;
Macon, Georgia
Swaziland, *Flagbearer*

Stone Mountain View
Ulla Marzec; Stone Mountain, Georgia
Sweden, *National Olympic Committee*

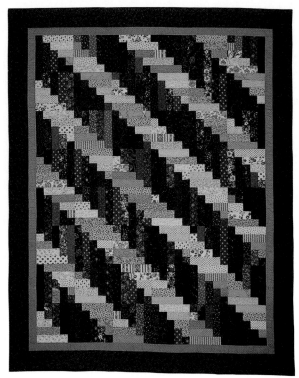

Half Log Cabin
Margaret LaBenne and Helen Gene Eberhart;
Tucker, Georgia
Sweden, *Flagbearer*

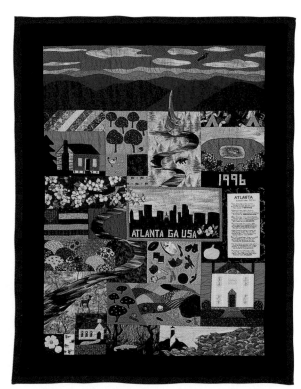

Georgia Welcomes the World
Jan Curran Vincent; Big Canoe, Georgia
Switzerland, *National Olympic Committee*

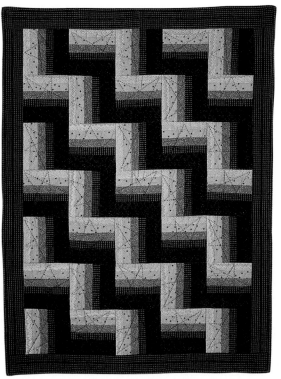

Stars Bright on Atlanta Night
Wanda Ingram; Cartersville, Georgia
Switzerland, *Flagbearer*

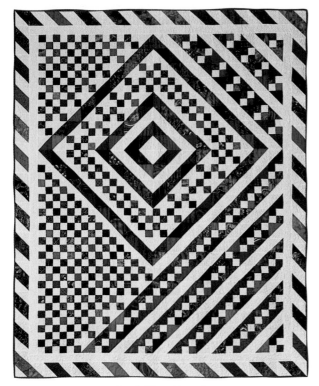

Jacob Goes Abroad
Jean Wolfe; Marietta, Georgia
Syrian Arab Republic, *National Olympic Committee*

Star Patch
LaVonne Timpson; Jonesboro, Georgia
Syrian Arab Republic, *Flagbearer*

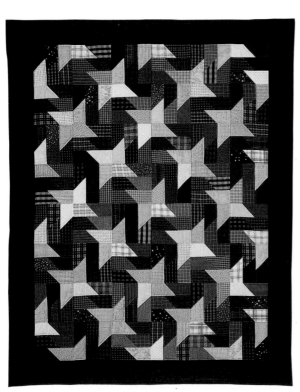

Plaid Stars
Gale Johnson; Riverdale, Georgia
Chinese Taipei, *National Olympic Committee*

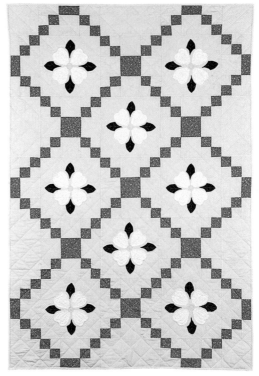

Dogwood Dreams
Alpharetta Junior Women's Club; Alpharetta, Georgia
Chinese Taipei, *Flagbearer*

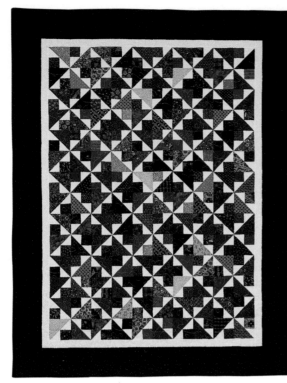

Harmony
Lois Jordan; Suwanee, Georgia
Tajikistan, *National Olympic Committee*

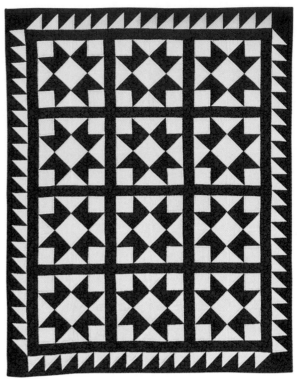

Georgia Blue Ribbon
Betty Ivey and Mildred Moore; Milledgeville, Georgia
Tajikistan, *Flagbearer*

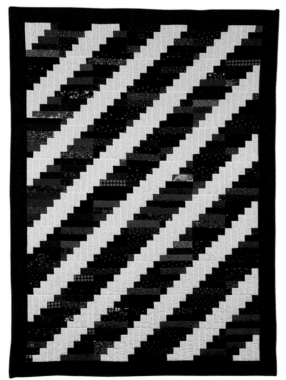

Togetherness
Thimble Pleasures Quilting Bee–East Cobb Quilters'
Guild; Smyrna, Georgia
United Republic of Tanzania, *National Olympic Committee*

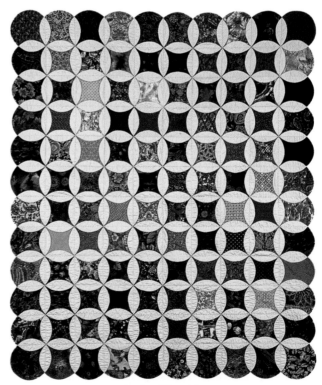

Circle of Friendship
Audrey Hiers; Blairsville, Georgia
United Republic of Tanzania, *Flagbearer*

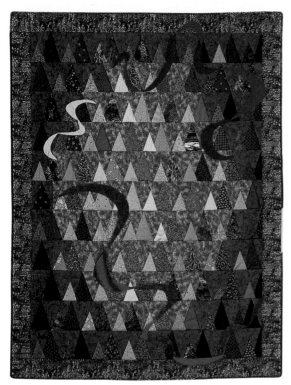

Celebration in the Pines
Marie Powell; Stockbridge, Georgia
Thailand, *National Olympic Committee*

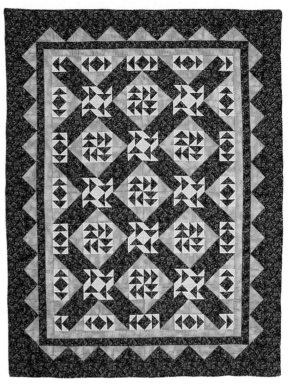

All Roads Lead to Atlanta 1996
Pat Benane; New London, North Carolina
Thailand, *Flagbearer*

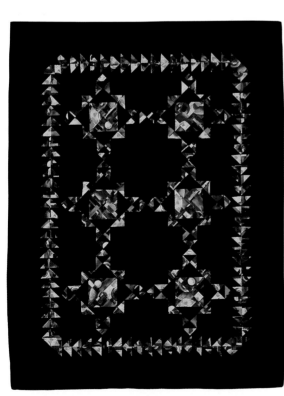

Friends
Martha Griffeth and Evelyn Honeycutt;
Macon, Georgia
Togo, *National Olympic Committee*

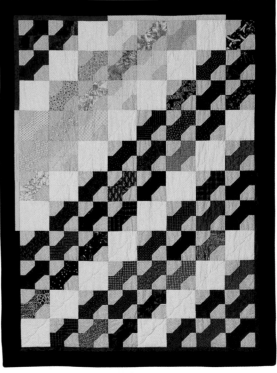

Ties That Bind
Gail Hankins; Macon, Georgia
Togo, *Flagbearer*

When Cotton Was King
Cotton Boll Quilters; Covington, Georgia
Tonga, *National Olympic Committee*

Allatoona's School Days
Allatoona Quilt Guild; Acworth, Georgia
Tonga, *Flagbearer*

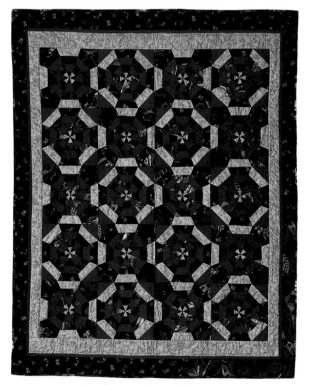

Cowboys & Indians Kaleidoscope
Margie Rogers; Decatur, Georgia
Trinidad and Tobago, *National Olympic Committee*

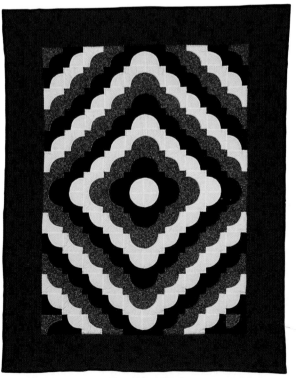

Friendship Circle
Laverne Card; Warner Robins, Georgia
Trinidad and Tobago, *Flagbearer*

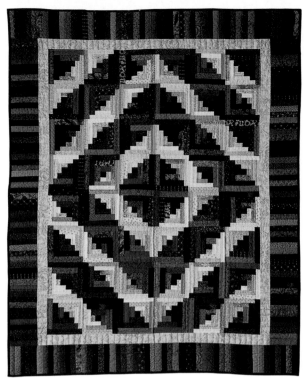

Uneven Log Cabin
Connie Vagtborg; St. Simons Island, Georgia
Tunisia, *National Olympic Committee*

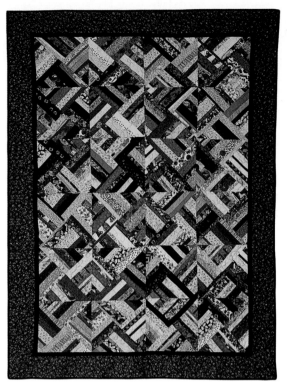

Joseph's Coat
Janice Spangler; Duluth, Georgia
Tunisia, *Flagbearer*

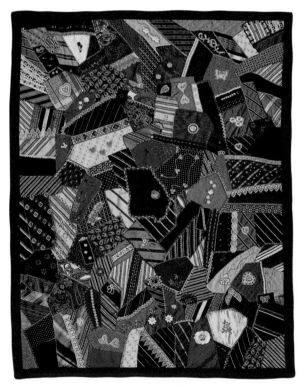

Crazy Quilt
Milladene Grant; Milledgeville, Georgia
Turkey, *National Olympic Committee*

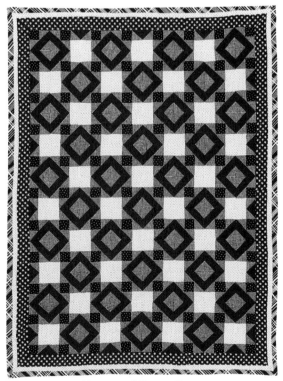

Memories of Stars & Stripes
Priscilla Hettema; Macon, Georgia
Turkey, *Flagbearer*

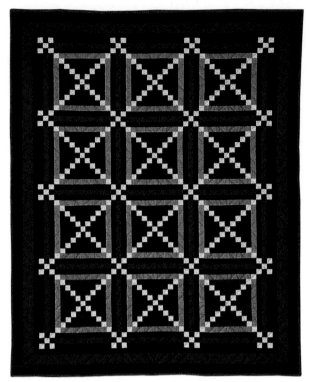

Chimneys and Cornerstones
Diane Taylor; Kennesaw, Georgia
Turkmenistan, *National Olympic Committee*

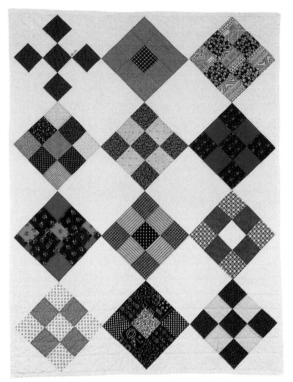

Friends of West Georgia
Gene Cooksey; Carrollton, Georgia
Turkmenistan, *Flagbearer*

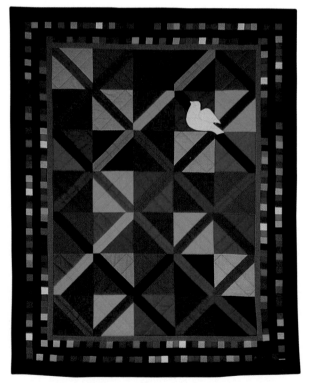

Peace
Violette Harris Denney; Carrollton, Georgia
Uganda, *National Olympic Committee*

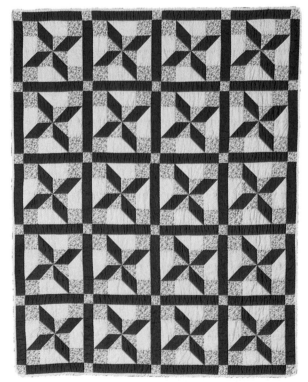

Clay's Choice
Lorna Reeder; Tiger, Georgia
Uganda, *Flagbearer*

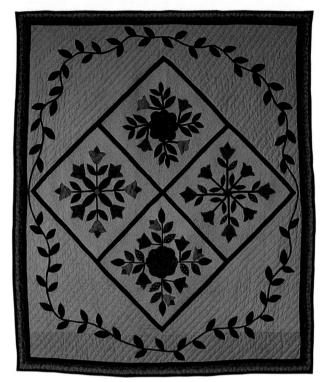

Nancy's Inspiration
Debbie Russell; Decatur, Georgia
Ukraine, *National Olympic Committee*

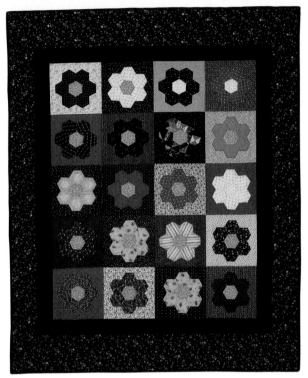

Appliquéd Grandmother's Flower Garden
McKibben Lane School; Macon, Georgia
Ukraine, *Flagbearer*

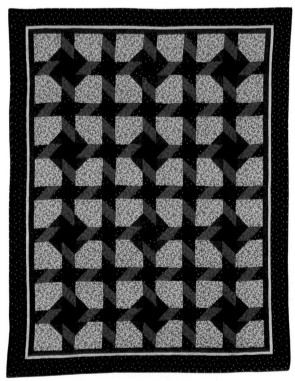

Star and Ribbons
Beth G. Culp; Atlanta, Georgia
United Arab Emirates, *National Olympic Committee*

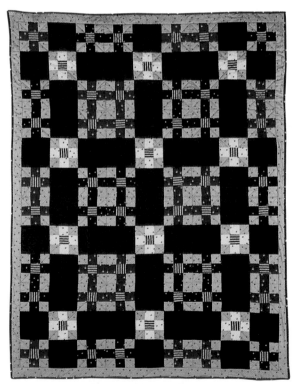

Stars and Stripes Forever
Mary Jeannette Perkins; Marietta, Georgia
United Arab Emirates, *Flagbearer*

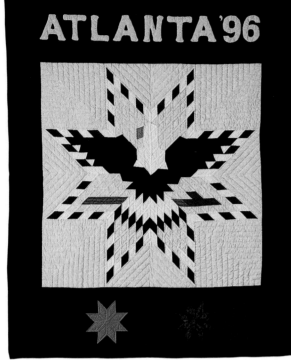

Eagle and Peace Pipe
Frances Hancock Cranford; Stone Mountain, Georgia
United States of America, *National Olympic Committee*

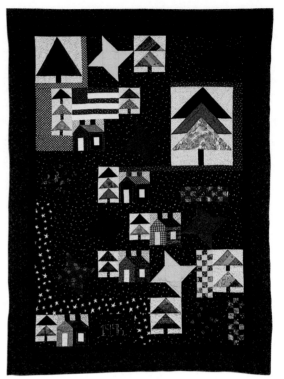

Friendship Pines
Lila Scott; Marietta, Georgia
United States of America, *Flagbearer*

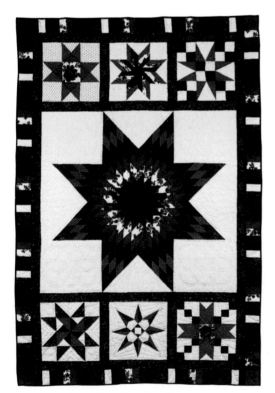

Lone Star Sampler
Priscilla Casciolini; Stone Mountain, Georgia
Uruguay, *National Olympic Committee*

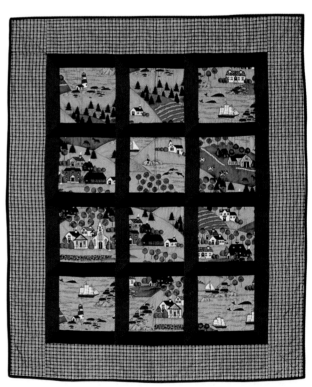

Pilgrim's Pride
Cheryl Vicinanza; Marietta, Georgia
Uruguay, *Flagbearer*

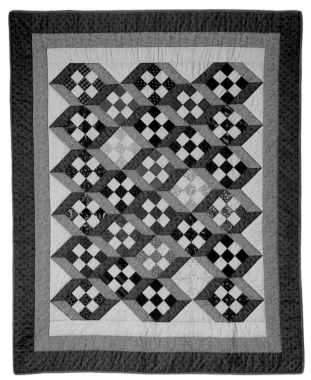

Fifth Dimensions
Willene England O'Neal and the fifth-grade class at
Bethlehem Elementary School; Bethlehem, Georgia
Uzbekistan, *National Olympic Committee*

Many Hearts Filled with Love
Grace Welch; Macon, Georgia
Uzbekistan, *Flagbearer*

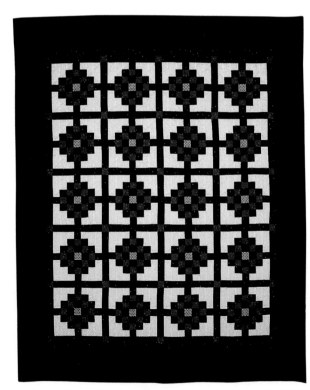

Bird's Eye
Corinne Schroeder; Hendersonville, Tennessee
Vanuatu, *National Olympic Committee*

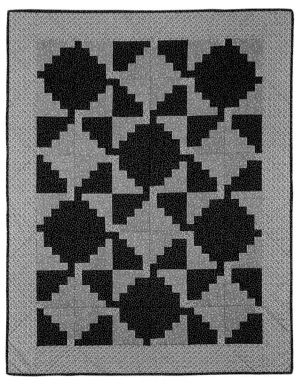

Half Log Cabin
Andrea Stolzenberg; Hayesville, North Carolina
Vanuatu, *Flagbearer*

Then and Now
Nellie T. Giddens; Macon, Georgia
Venezuela, *National Olympic Committee*

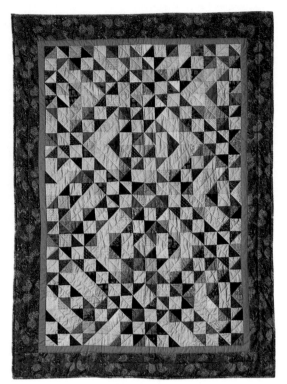

Woven Colors
Sue Carithers; Macon, Georgia
Venezuela, *Flagbearer*

Small Town Squares of Georgia
Evelyn Poore and Jane Price; Monticello, Georgia
Vietnam, *National Olympic Committee*

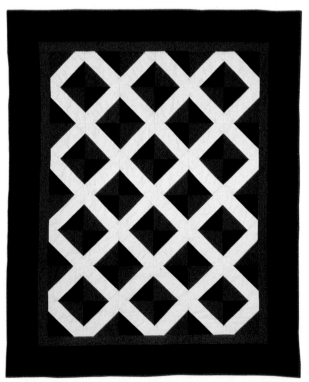

Our Crossroads in Georgia
Marissa Markley; Snellville, Georgia
Vietnam, *Flagbearer*

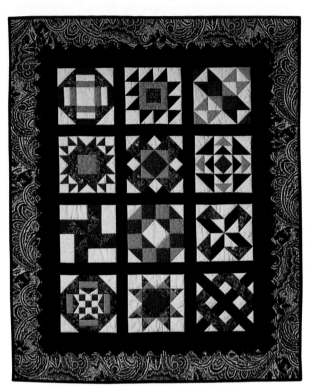

Pioneer Sampler
Barbara Morris; Kennesaw, Georgia
Virgin Islands, *National Olympic Committee*

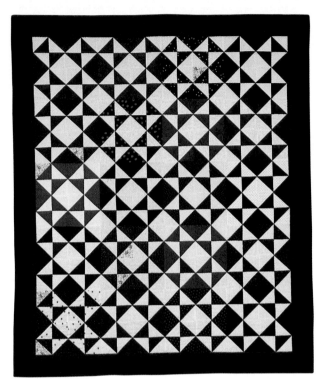

Broken Dishes
Margaret LaBenne and Peggy Littrell;
Tucker, Georgia
Virgin Islands, *Flagbearer*

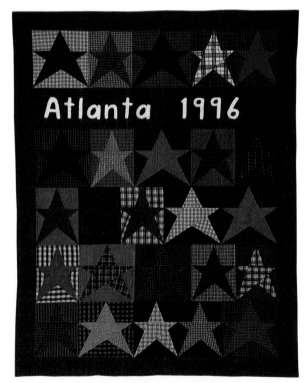

Centennial Stars
Joan Nickels; Gainesville, Georgia
Western Samoa, *National Olympic Committee*

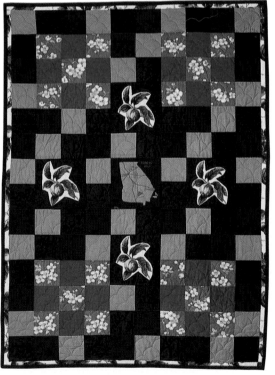

Georgia on My Mind
Judy Owen; Woodstock, Georgia
Western Samoa, *Flagbearer*

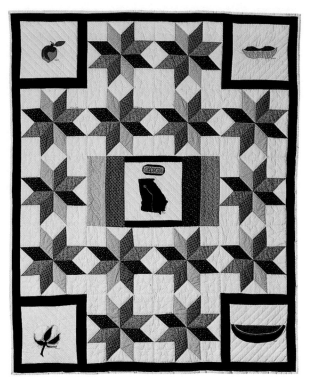

Homeland
Edith Johnson; Atlanta, Georgia
Yemen, *National Olympic Committee*

Stars Over Georgia
Lake Park Area Historical Society; Lake Park, Georgia
Yemen, *Flagbearer*

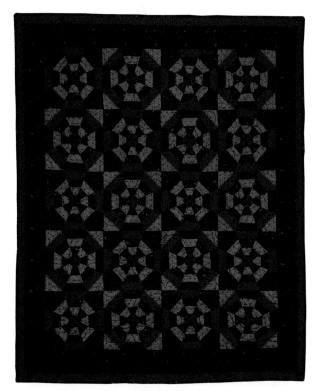

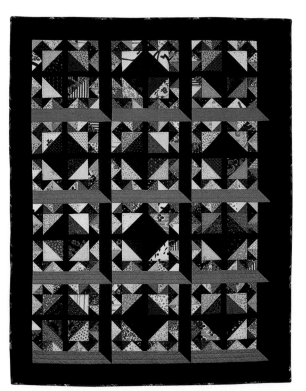

Spider Web
Judie Glaze; Doraville, Georgia
Yugoslavia, *National Olympic Committee*

Scrap Windows
Tess Thorsberg; Macon, Georgia
Yugoslavia, *Flagbearer*

Around the Twist
Sissy Anderson; Lithonia, Georgia
Zaire, *National Olympic Committee*

The Cabins of Stone Mountain Village
Stone Mountain Woman's Club; Lilburn, Georgia
Zaire, *Flagbearer*

Tara Trails
Tara Quilt Guild of Clayton County;
Stockbridge, Georgia
Zambia, *National Olympic Committee*

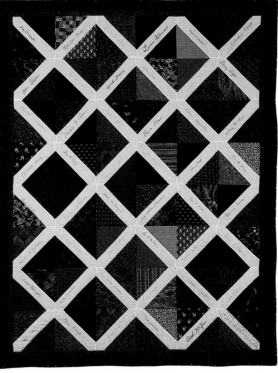

Friendship Quilt
Civic Woman's Club of Milledgeville;
Milledgeville, Georgia
Zambia, *Flagbearer*

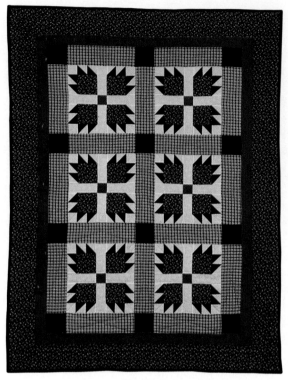

Bear Paws
Martha Spencer, Douglasville, Georgia
Zimbabwe, *National Olympic Committee*

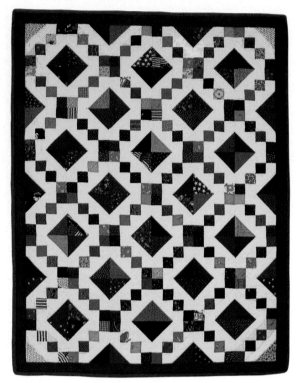

Georgia Buckeye 1996
Weak-End Stitchers—Heart of Georgia Quilt Guild,
Macon, Georgia
Zimbabwe, *Flagbearer*

Index of the Quiltmakers

Special Thanks

Thanks are extended to the quilters and quilt groups who made quilts above and beyond the number needed for the Olympic Games Gift of Quilts.

Allatoona American Legion; Allatoona Quilt Guild; Employees of the American Cancer Society of Stone Mountain; Bethlehem Senior Center; Cobb County Vision Program; Flowery Branch Homemaker's Club; Foster Grandparents of Denton, Texas; Golden Needles Quilters; Horseshoe Bend Quilters; Leslie-DeSoto Hobby Club; Newton-Coweta Chapter, Professional Secretaries International; Northside Shepherd's Center; Northwest Georgia Travel Association; Rowland Elementary School; St. Stephens Quilters; Shamrock Quilters; West Georgia Quilt Guild; Ruth Altemus; Jan Antranikian; Charlotte Baker; Dotty Bailey; Ray Barreras; Cathy Bradley; Nancy Brischler; Mozell Brown; Kay Caldwell; Susan Carroll; Della Cohen; Billie Crumly; Darlyne Dandridge; Mati Daubenmire; Annie Ruth Davis; Juanita Davis; Sarah Davis; Ronnie Durrence; Karen Furnish; Irene Gardner; Helen Gibbs; Ann Groves; Maggi Hall; Melinda Harman; Rhonda Hines; Linda Huff; Jean Kingsley; Judith Kosik; Julie Krickel; Patricia Lee; David Light and Dorothy Collins; Mabel Lucas; Dorthey McCauley; Suzie McWhirter; Lois Meixsel; Marrilee Miles; Jane Murray; Kathleen Norris; Mary Phillips; Inez Presnal; Magdalene Pruitt; Shirley Rathkopf; Louise Rice and Caroline Chandler; Doriene Rowe; Judy Rutkowski; Evelyn Saum; Corinne Schroeder; Rena Snapp; Ruby Stuart; Eleanor M. Taylor; Gail Taylor; Carolyn Vail; Lea Weaver and Doris Loftus; Mary Wigmore; Ginny Wineinger; and Ann Young.

PHOTOGRAPHY CREDITS

William C.L. Weinraub, Georgia Quilt Project: Cover; page 7, lower right; page 12; page 22; page 28; page 34; page 36, above; pages 38-138.

William F. Hull, Atlanta History Center: page 7, left; page 8, right; pages 9–10; pages 20-21; pages 26-27; pages 32-33; page 36, below.

Anita Zaleski Weinraub: page 7, upper right; page 8, upper left, lower left.

John O'Hagan: page 37.

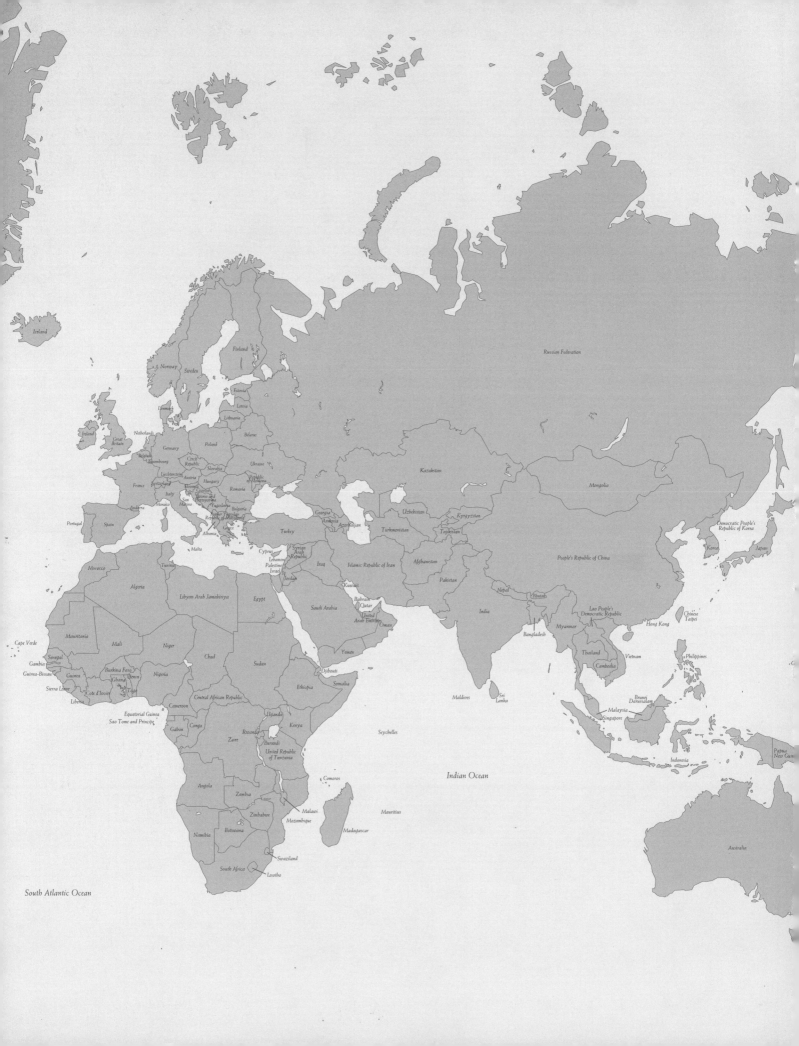